# MAINE PLACES, MAINE FACES

MAINE P

MAI

**Commonwealth Editions**
Beverly, Massachusetts

LACES
NE FACES

Photographs by Fred J. Field

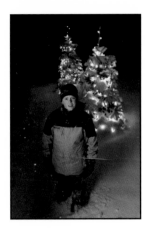

*This book is dedicated to our son, Robert Eaton Field. It's a true honor to be your dad, Robert, and I thank you with all my heart for all the great things you have taught me about life, living, altruism, spirit, grace, and fun. There has never been a better son!*

ISBN 978-1-933212-44-9

The following photographs are reproduced courtesy of Blethen Maine Newspapers: pages 15, 21, 29, 39, 49 bottom, 68 center, 70 top, 100 bottom, 112 bottom, 121 top, 126. All are copyright © 2008 by Blethen Maine Newspapers. My thanks to Chuck Cochrane and Brian Fitzgerald.

Cover design by John Barnett/4 Eyes Design
Interior design by Anne Lenihan Rolland
Printed in Korea

Commonwealth Editions is the trade imprint of Memoirs Unlimited, Inc., 266 Cabot Street, Beverly, Massachusetts 01915. Visit us on the Web at www.commonwealtheditions.com.

Visit Fred J. Field on the Web at www.fredfield.com.

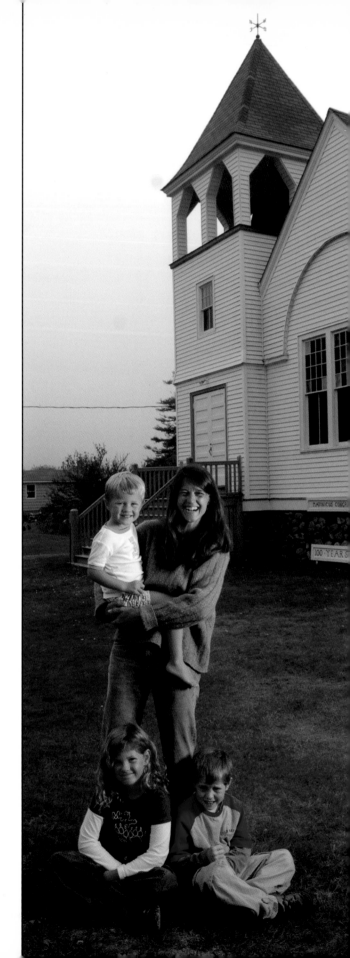

# FOREWORD

Wow.

Maine is easy to photograph but hard to capture. Part of the problem is, the scenery is so overwhelming, it's easy to miss the smaller scenes and, quite often, the people as well. The result of this phenomenon (I call it the Portland Head Light Effect) is a beautiful collection of pictures but one that often lacks emotion and a sense of depth.

Somehow, in this gem of a book, Fred Field has avoided this—by focusing his extraordinary eye on images we all know but don't often consciously see. The result is one of the most interesting, moving, and beautiful studies of Maine that I have ever encountered.

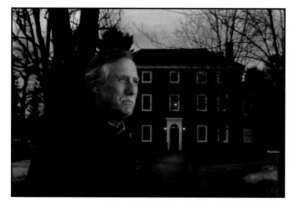

I'll be honest: I've never been a big fan of the photograph as art. It is, after all, the ultimate in representation—what you see is generally what is. Painting, on the other hand, can often tell us more about the subject by expressing mood and nuance of emotion and sometimes mystery. One of my favorite paintings, for example, is a small landscape of a field in front of a patch of woods; what's cool about it is the almost magical suggestion of something going on—just beyond our vision—in those woods, something we can't quite discern.

This can be done in photographs, but it's hard and it's especially hard when the subject is a place that positively screams, "Look at me! I'm scenery!"

But Fred has done it.

Look at page 33, for example. It's impossible to look at that picture without wanting to know more about this woman and her story—what the day just ended was like, whom (if anyone) she's meeting later, as the light fades, and where she goes from here. The shot tells us something about her and about Down East Maine, but it suggests much more—and it allows us to meet the art halfway by supplying answers from the depths of our own experiences and imagination.

Wow.

Another special quality of these pictures is the light. Great representational art is often (maybe always is) about light. The Dutch masters, the Impressionists, Hopper, the Wyeths of our own day (and check out the work of my friend, Maine artist Linden Frederick)—all somehow capture light itself: luminous, dark, subtle, fading, deep, and always suggestive. It's the light that helps us to see into the subject, beneath the surface. Maybe that's why the word *illumination* has a double meaning: first, and most literally, to light up, but also to explain and, well, to illuminate.

*Above:* Angus King in front of Massachusetts Hall of Bowdoin College,
*Left:* On Matinicus, Maine's most remote island, eighth-generation islander Natalie Ames and her husband are raising their three children, Isabella, Ezekiel, and Gardner.

The word *photography,* after all, comes from a Greek phrase which means "drawing with light" and that's exactly what Fred seems to do: His use of light is part of the message of each photograph. Look at the shot on page 58; the light from the cabin envelops the lobsterman pulling the line, wrapping him in a mantle of depth and, yes, a little mystery.

This is subtle stuff. Any of us with a fairly decent point-and-shoot could have taken similar pictures and captured the basics of the scene—call it 85 percent of the scene. A better camera and a little practice would get us up to maybe 90 percent. But the last 10 percent is what makes all the difference, and it comes from long practice, experience, and, most importantly, an innate sense of where to stand and when to press the shutter. This artistic gift is what distinguishes ordinary photos from art; my guess is that I could quit everything, buy a five-thousand-dollar camera, go back to school, and shoot every day—and still not achieve what Fred has given us in this book.

The other piece that makes this collection exceptional is its focus on people as well as scenes. Again, Maine is so spectacular, it's tempting to use people as not much more than props to provide scale or context to the gorgeous landscapes. But Fred's people are an essential part of his story; often the landscapes are context for them, not the other away around.

Take the shot of the blueberry harvest on page 32, for example. Who would have ever thought to capture this essentially Maine experience from the point of view of the blueberry? But the work implied by that full box is also unmistakably etched in the form of the man behind it in the field. Somehow, this one picture captures the whole enterprise in an almost biblical sense—the land, its fruit, and this most ancient form of labor.

Wow.

Finally, unlike most "picture" books, this is a work you can come back to over and over—and each time you pick it up, you'll find something new. The play of light on a pair of hands, clouds building into an impossibly blue sky, the contrast between a lighted interior and the fading day outside, a window opening to a lake at dawn—all draw us in and hold us for a moment in that special place between the here-and-now and the region of imagination and dreams.

This is really the stuff of poetry—using familiar images in unfamiliar ways to make us pause, reflect, and learn something about the world around us—in this case, the wonderful state of Maine—and, perhaps more importantly, to learn something about ourselves. So look through the pages that follow, but then go back and savor the images one by one. There are lots of stories in here, and the neat thing is, you get to help write them.

Wow.

This is quite a book.

—*Angus King, Brunswick, Maine, winter 2008*

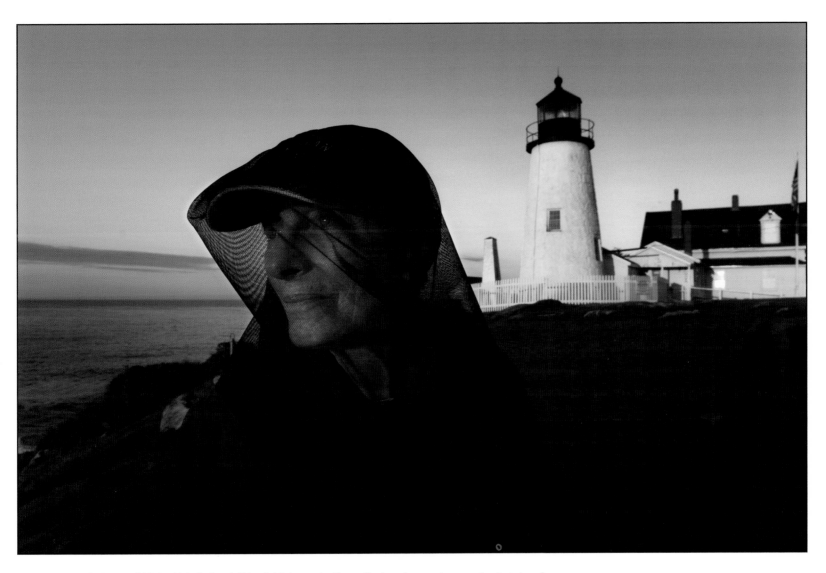

At Pemaquid Point Light in South Bristol, Maine, artist Frema Rauh welcomes dawn on the first day of summer wearing a net to repel black flies. With dramatic streaks of granite reaching to the sea, Pemaquid was squeezed and shaped by massive geological pressures thousands of years ago. It has been the site of many shipwrecks, including the 1635 wreck of the British ship *Angel Gabriel,* in which five people lost their lives.

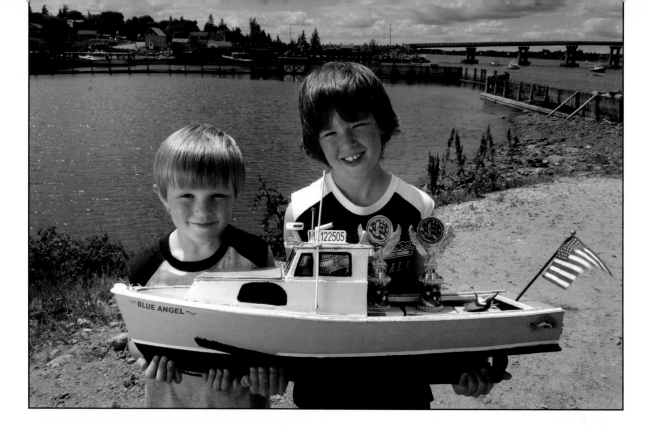

Jonesport brothers Tyler Alley, six, and Tristan, nine, each took a first place at the annual race of radio-controlled model lobster boats on Beals Island. Since it was settled in 1770, residents of this island have made their living from the sea.

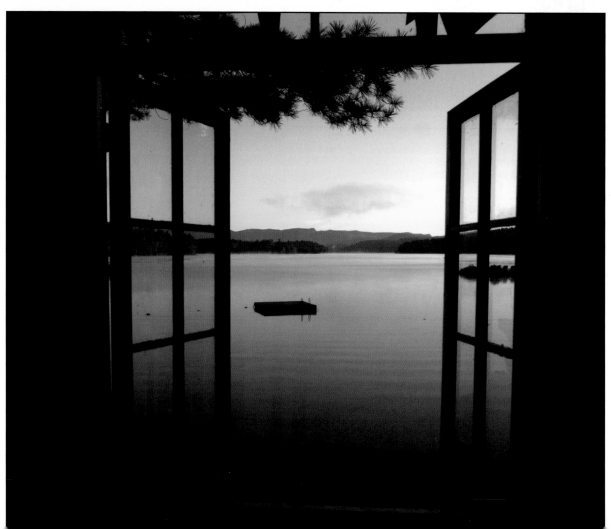

This view of Kezar Lake at sunrise was taken from a window at Quisisana resort in Lovell.

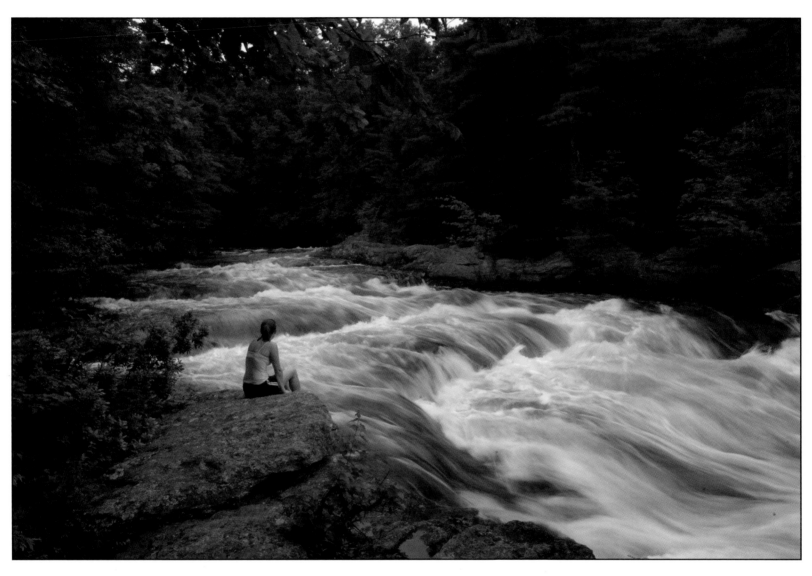

Kathy Egan sits by the flowing natural border between Maine and New Hampshire formed by the Salmon Falls River near Lebanon. The river rises from Great East Lake in Acton.

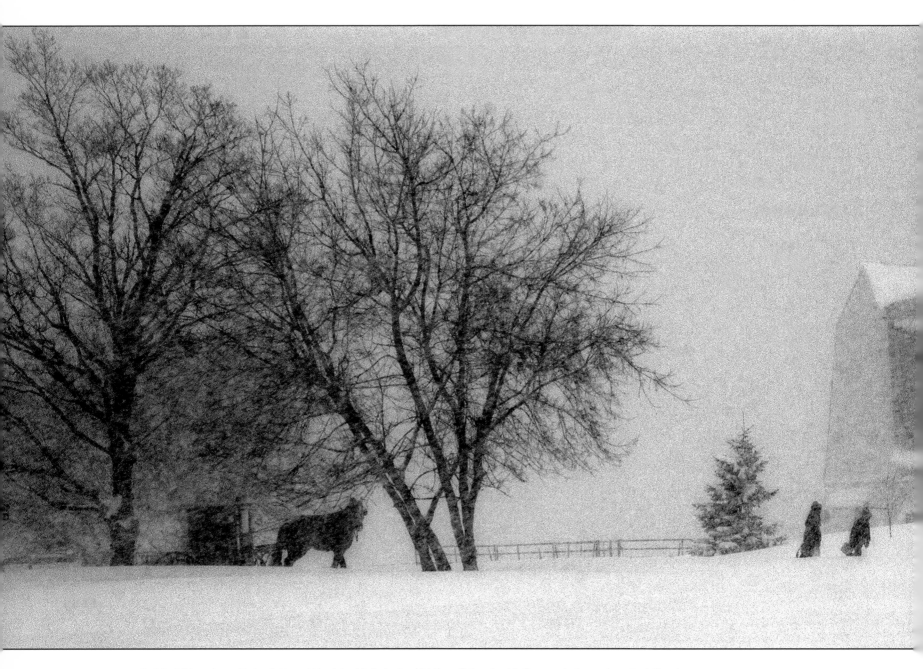

Amish children Jonas Esch, eight, and his sister Malinda, ten (right), walk to school in Smyrna during an Aroostook County blizzard that has closed all other schools in the region. Others (above) make their way by horse-drawn buggy. The Amish pride themselves on self-sufficiency and rarely call off school for extreme weather. Thinly populated Aroostook County is attractive to the Amish, who have seen other groups encroach on their lands elsewhere in the nation. The first Amish family moved to Smyrna in 1996, and families from Tennessee, Michigan, Iowa, and Maryland have followed.

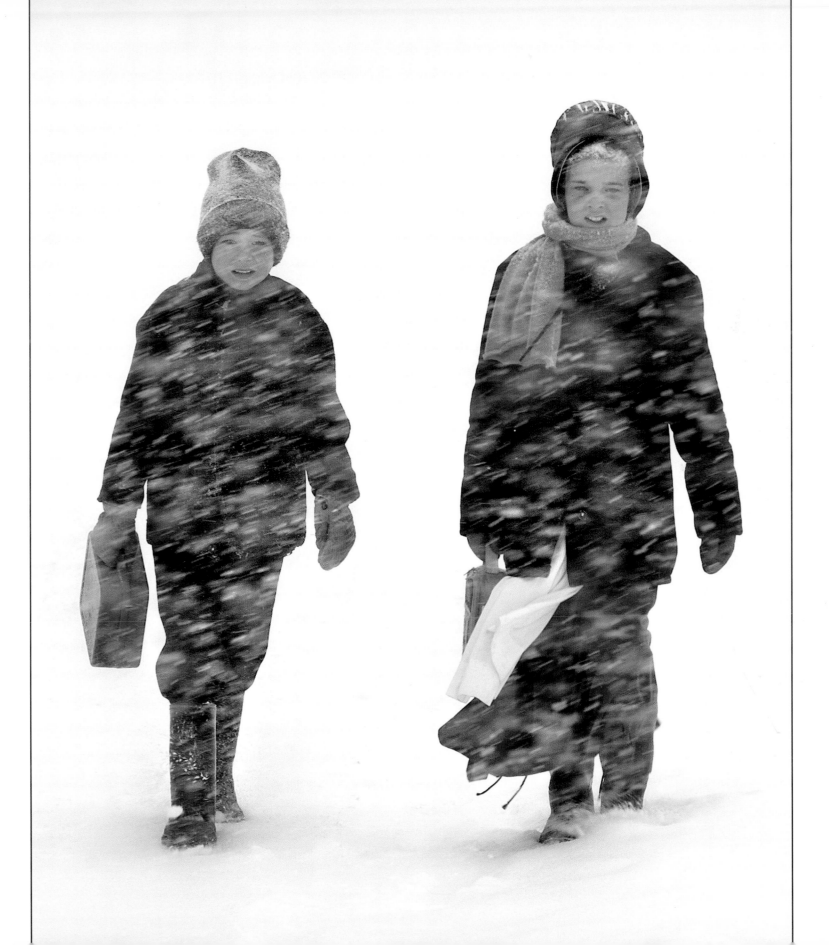

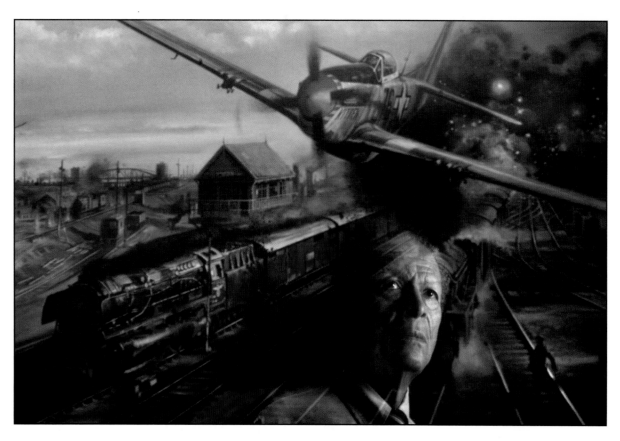

James Sheppard of South Portland is one of the surviving Tuskegee Airmen, an elite group of African American fighter pilots who served in World War II. The painting by Robert Bailey, "Tuskegee Junction," celebrates a raid by the Airmen on enemy munitions trains in July 1944.

On Matinicus, Maine's most remote island, Max Van Dyne, five, and his sister, Emma, seven, make the daily trek home during school lunch break.

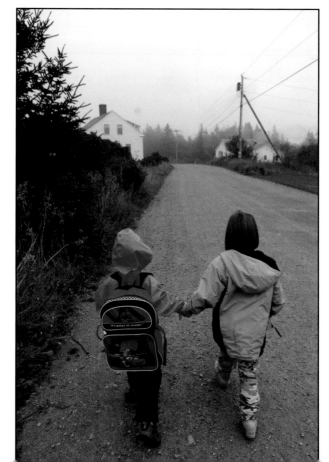

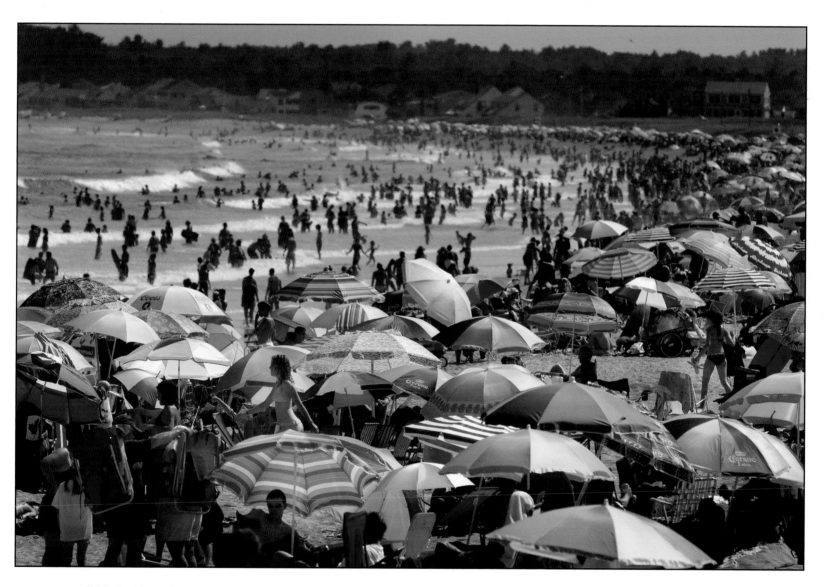

Old Orchard Beach is the place to be on a hot mid-July afternoon. The apple orchard from which the town took its name, a landmark to sailors for many years, was located above this long sand beach. For many years the Grand Trunk Railroad, opened in 1853, connected Montreal to Old Orchard Beach, enabling Canadian visitors to flock here. Today rail service from Boston's North Station brings passengers from Massachusetts.

The full moon rises beyond Cape Neddick Light in York. In 1977, when *Voyager II* was launched to photograph the outer solar system, it carried artifacts designed to teach extraterrestrial civilizations about Earth. One of the images it carried was a photo of this lighthouse, known familiarly as Nubble Light.

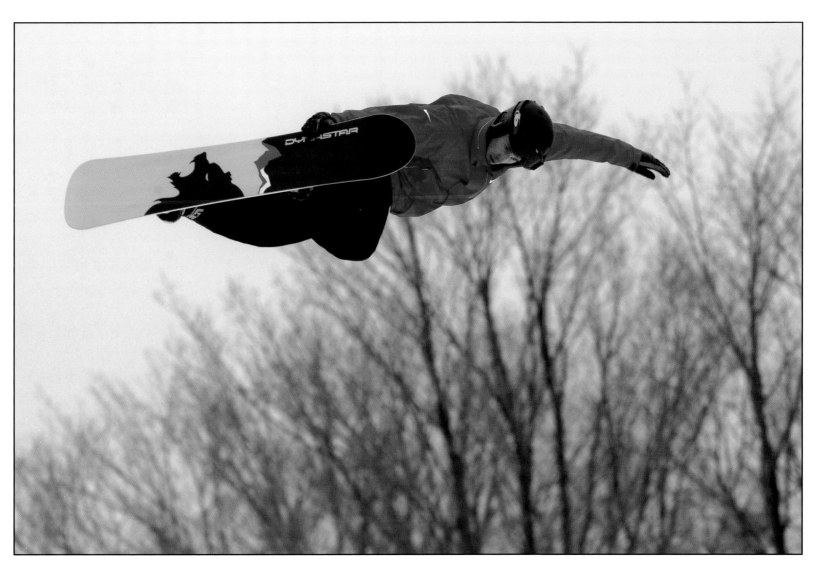

Seth Wescott of Carrabasset Valley catches major air while christening the four-hundred-foot Super Pipe named for him at Sugarloaf USA. Wescott won a gold medal in the first-ever Olympic snow-board-cross event in Turin, Italy, in 2006.

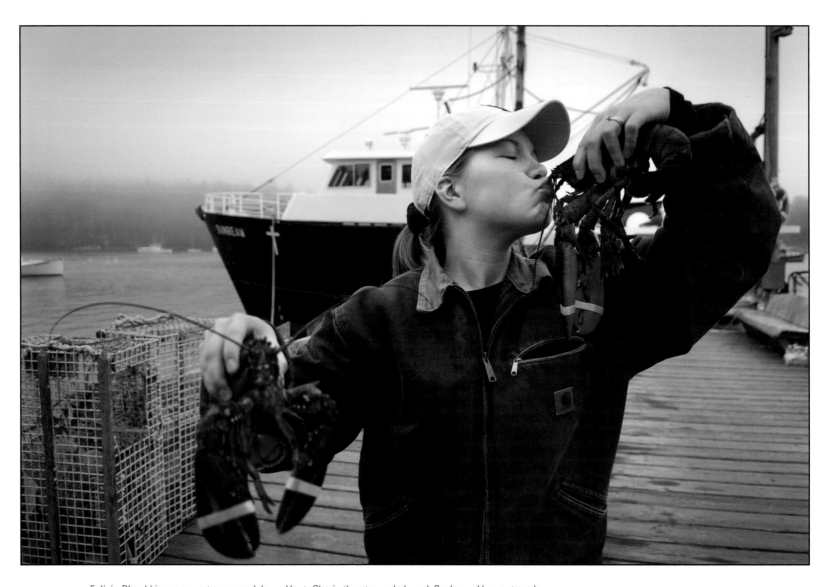

Felicia Bland kisses a crustacean on Isle au Haut. She is the steward aboard *Sunbeam V,* an outreach vessel for the Maine Seacoast Mission Society. In 2007 Maine lobstermen caught 56.1 million pounds of lobster valued at $248 million dollars.

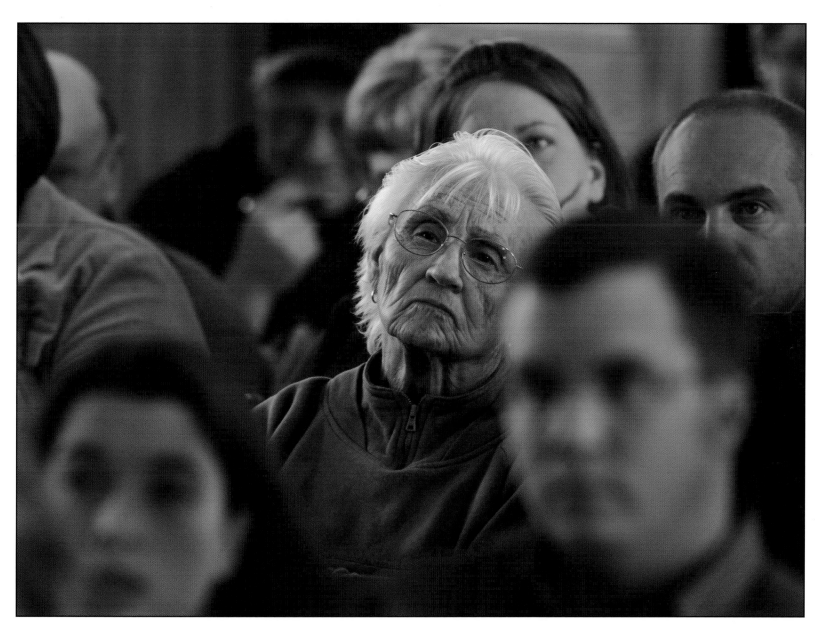

Anna Seamans of St. Albans listens intently during town meeting. This Sebasticook Valley community has eighteen hundred year-round residents, and the population swells by another thousand during the summer, when Big Indian Lake is a major attraction.

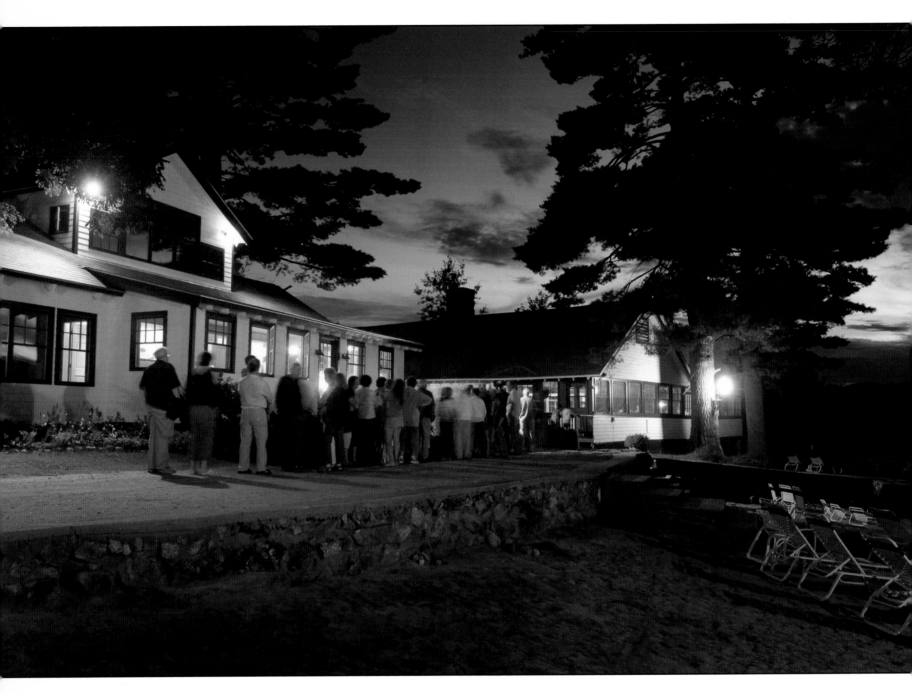

A line forms every summer evening outside the theater at Quisisana resort on Lake Kezar in Lovell. The quality of the music is remarkable, especially since performers double as service staff, and rehearsals must be sandwiched between making beds and chopping lettuce. Many performers, who range in age from eighteen to thirty-three, have professional credits. Alumni have landed on Broadway and in the Metropolitan Opera.

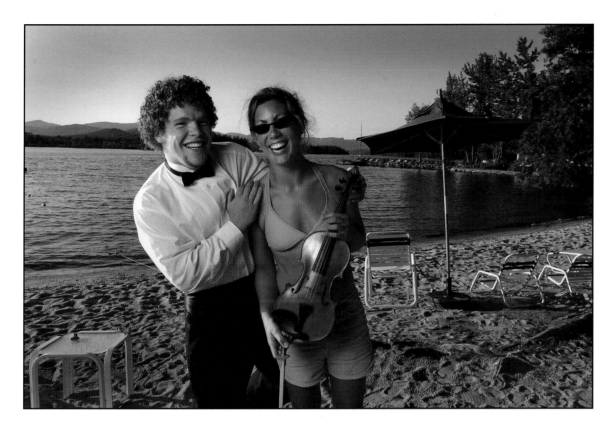

Singer Michael McCann and violinist Liz Coulter share a light moment on the beach at Quisisana hours before show time.

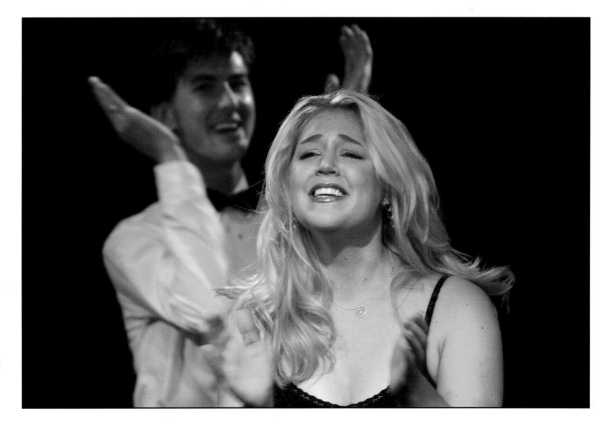

Elizabeth Johnson performs with Toby Yatso at Quisisana. Resort staff is recruited from top-notch music schools such as Julliard and the New England Conservatory.

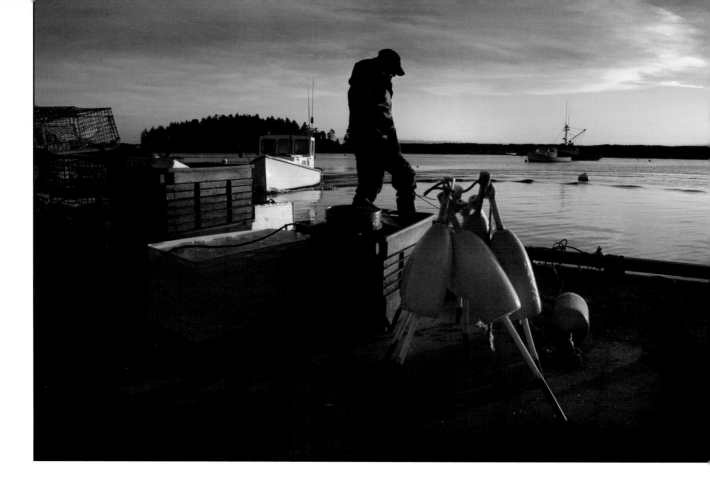

As day dawns at Five Islands Harbor in Georgetown, a sternman waits to be picked up for a day of lobstering.

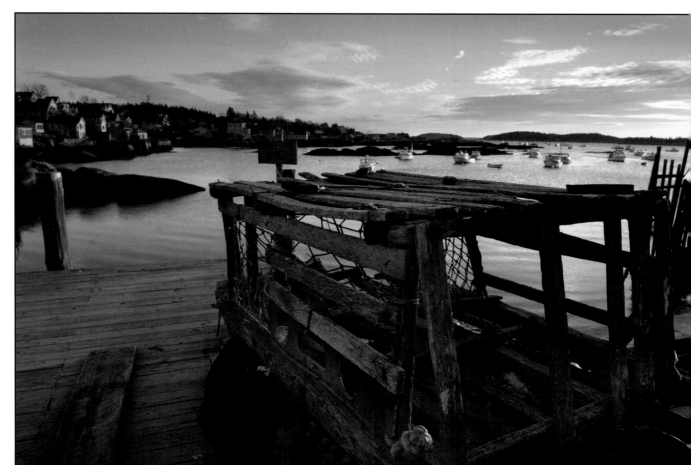

The morning sky brightens behind a traditional wooden lobster pot on a dock in Stonington.

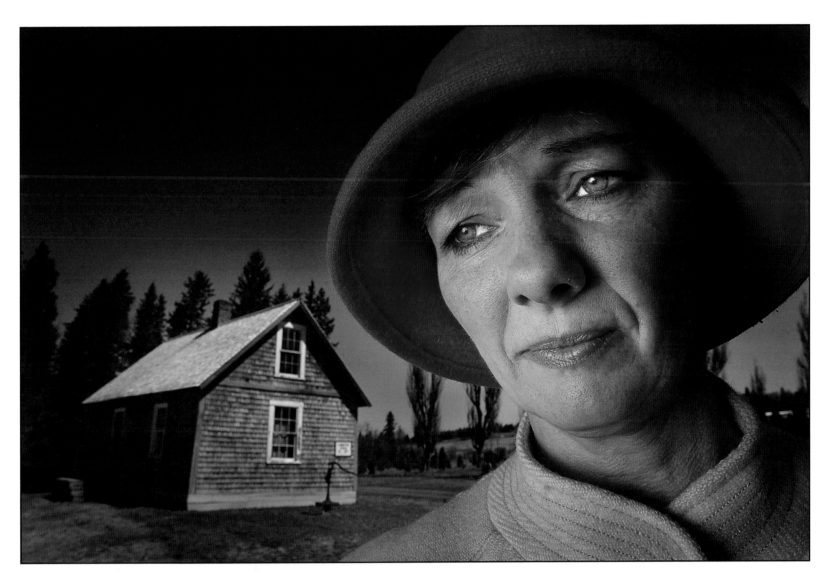

Local historian, teacher, and filmmaker Brenda Jepson stands outside one of the original *stugas,* small houses offered to Swedes in 1870 when they agreed to settle in a remote area of Aroostook County near what was then a disputed border with Canada. In 2003 the international spotlight shifted to this placid town of New Sweden when the nation's worst case of mass arsenic poisoning occurred. It was traced to a disgruntled parishioner who spiked the coffee pot at church.

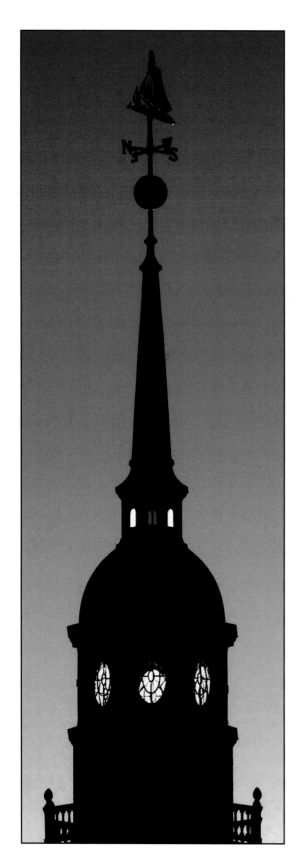

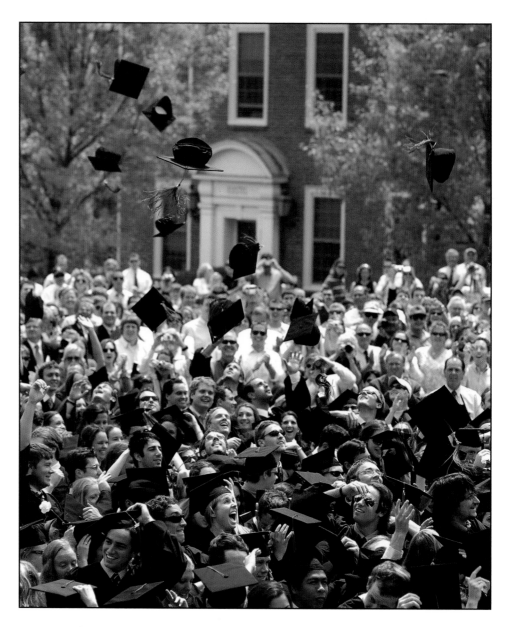

Sunrise backlights the Miller Library tower (left) at the heart of the Colby College campus in Waterville. The tower is topped by a weathervane depicting the sloop *Hero*. Colby was originally chartered as the Maine Literary and Theological Institution in 1813, when Maine was still a part of Massachusetts. Mortarboards fly at the conclusion of commencement (above). Colby is the twelfth-oldest independent liberal arts college in America.

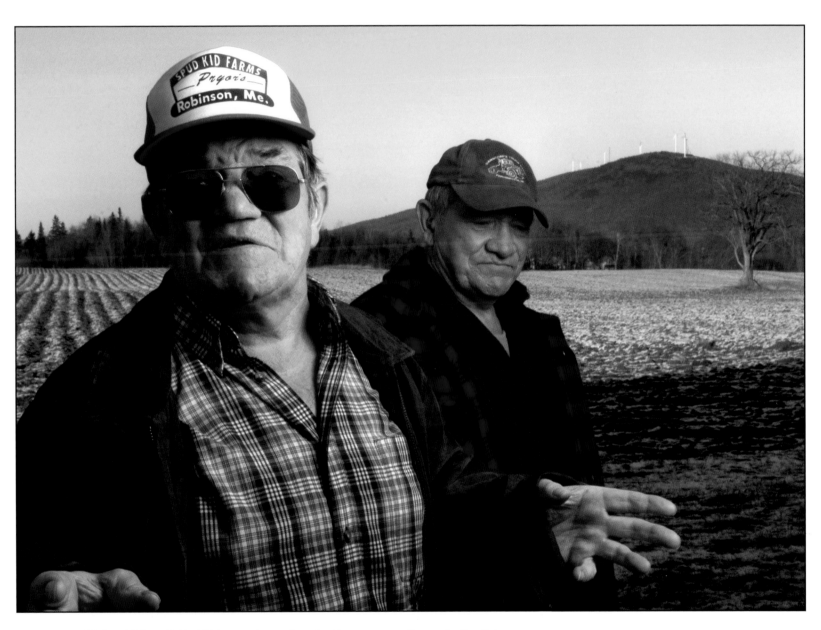

Wallace W. Pryor (left) of Blaine stands proudly on land he grew up on. Younger brother Dale now farms land in nearby E Plantation. Both love Aroostook County. "The farther north you go, the friendlier people get," says the elder Pryor. "Go a little farther north and they won't even let you out of the house!"

Rodney Stacey of Parsonsfield has been evaporating maple sap to make maple sugar for more than fifty years at his sugarhouse near Kezar Falls. In a good year, one large maple tree may offer up to sixty gallons of sap. Sixty gallons boil down to one and a half gallons of syrup.

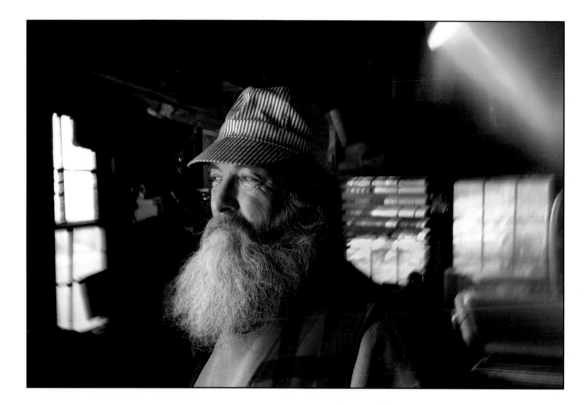

Steam rushes from Ted Greene's evaporator as he makes maple syrup in Sebago. In 2007 Maine ranked second of all maple syrup–producing states, with 225,000 gallons. Production can vary wildly from year to year due to changes in snow depth, temperature, and even wind direction.

Ted Greene displays small jars of maple syrup showing the color of each batch he makes. The lighter the color the mellower the taste. Maine maple syrup is made by boiling the sap of *acer saccaharum,* commonly known as the rock maple or sugar maple.

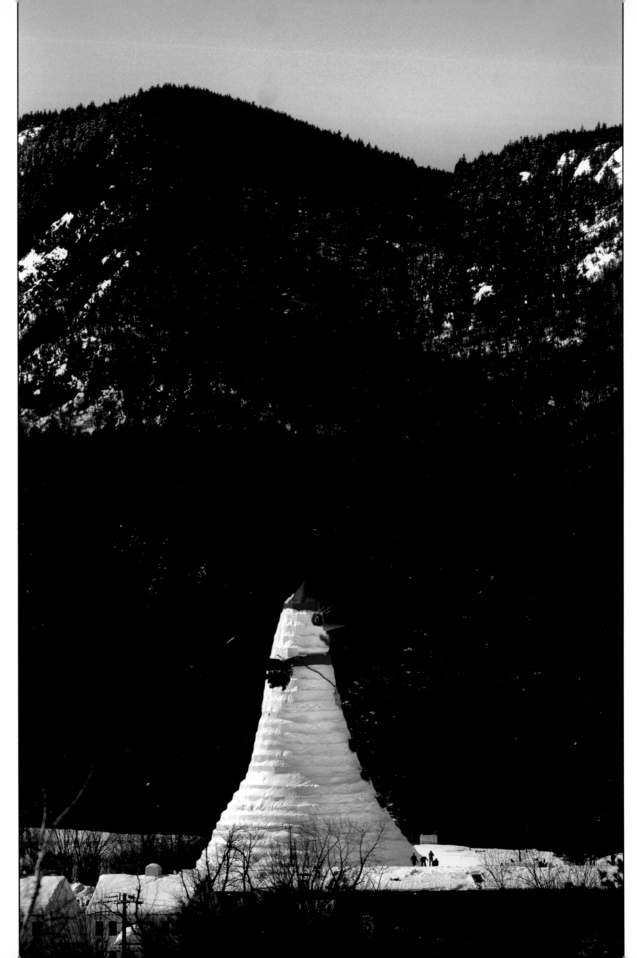

In Bethel, at 122 feet tall, "Olympia Snow Woman" towers above homes and men working to clear snow from a roof. Named for Maine senator Olympia Snowe, the creation broke Bethel's 1999 record for world's tallest snow man, previously held by the 113-foot 7-inch "Angus King of the Mountain"—in honor of former governor Angus King.

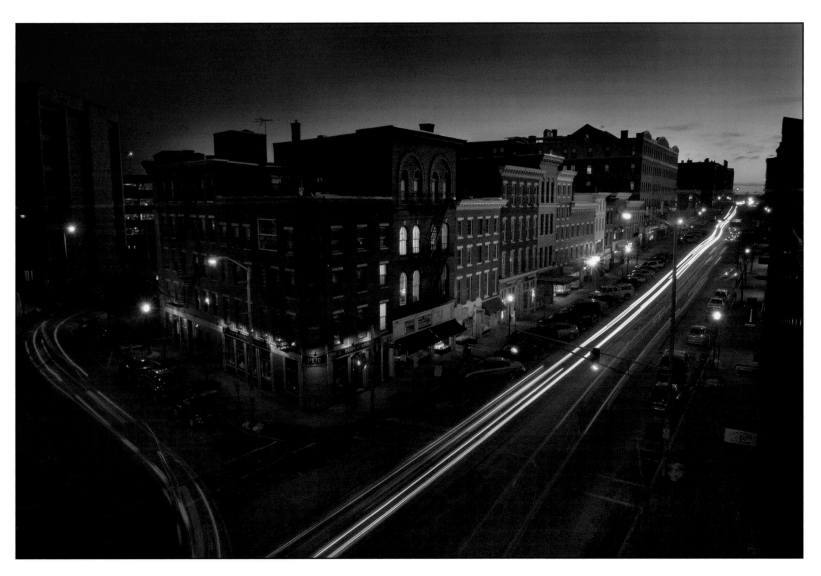

Traffic streams through the heart of downtown Bangor during a twenty-second time exposure. Today, Bangor is Maine's second largest city, but for several decades in the first half of the nineteenth century, Bangor was number one—as undisputed lumber capital of the world.

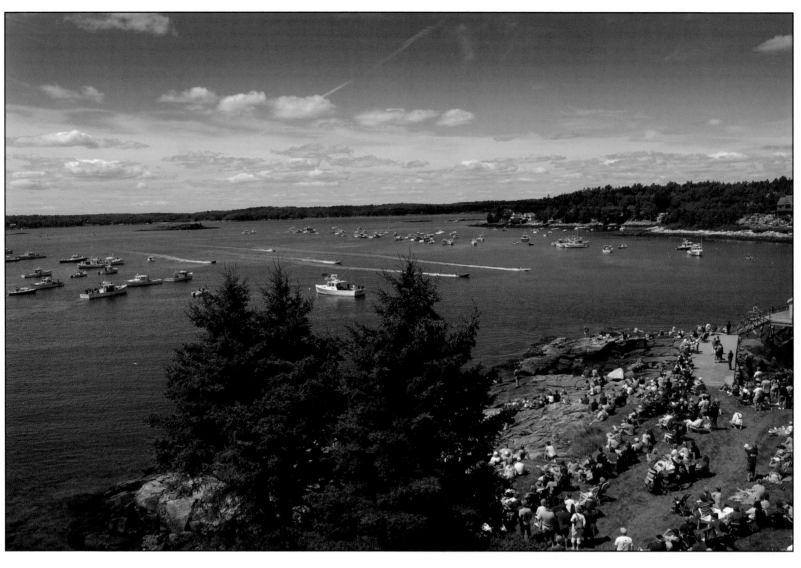

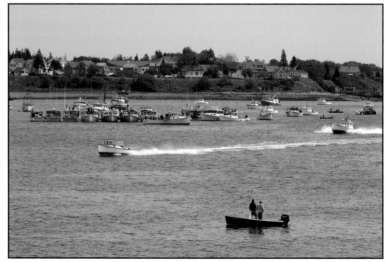

Lobster boats race off Fort William Henry in Bristol (above). Races follow a circuit of coastal towns each summer. The clear winner of a lobster boat race in Jonesport (right) crosses the finish line on July 4.

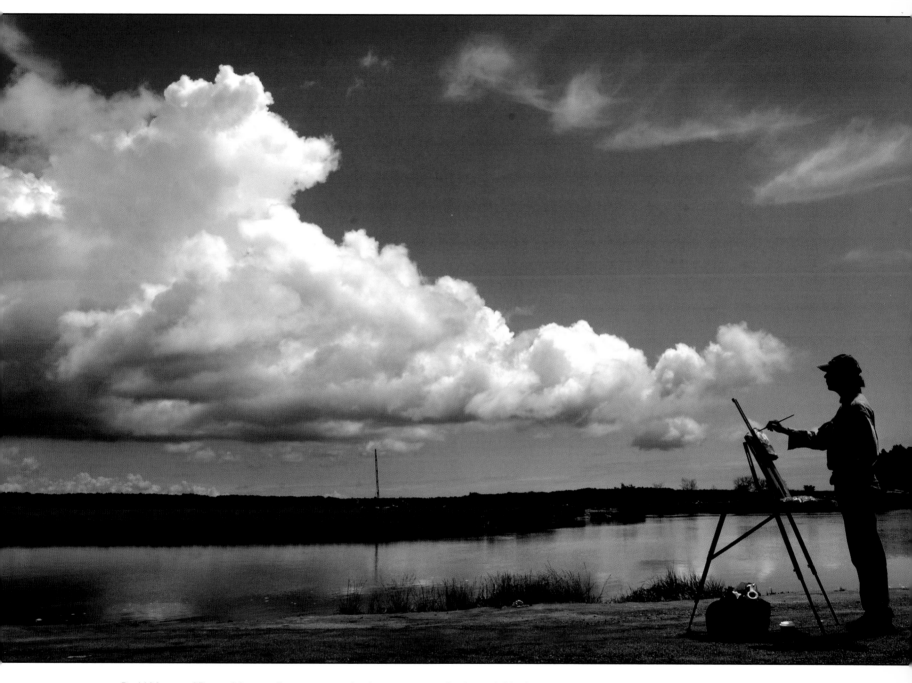

David Matson of Brunswick uses oils to capture a cloud-swept scene at Scarborough Marsh. An
Episcopal priest, Matson says, "I love things that are beautiful and painting is a way of honoring that."

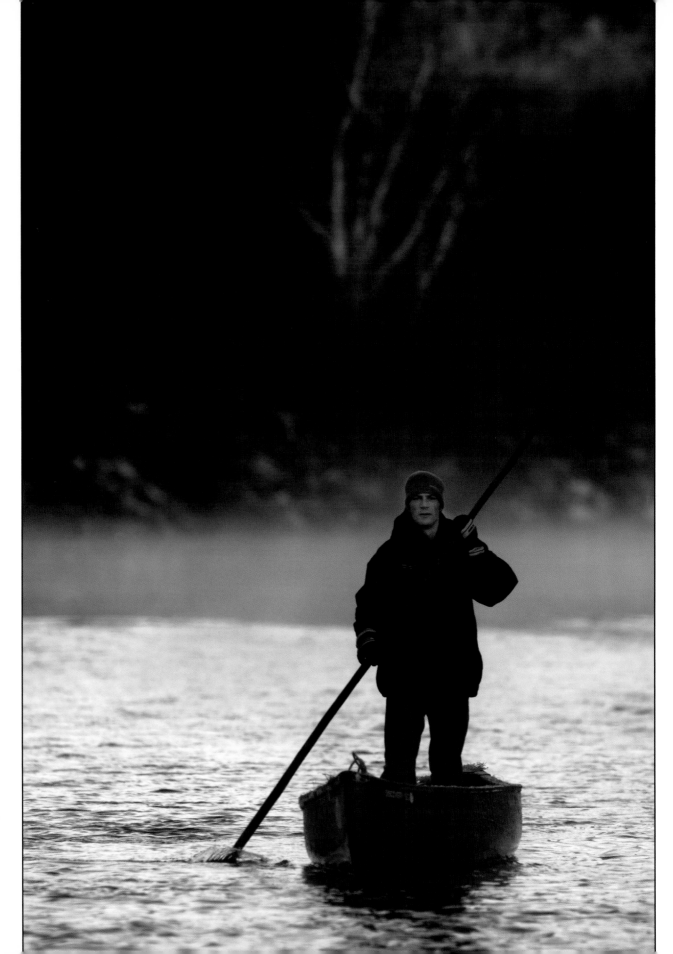

Leo Trudel canoes the border between the United States and Canada along the St. Francis River near Big Twenty Township. Trudel was raised "off the grid" in one of the most remote sections of the state. For a time he and his family were the only American citizens who could cross the international border at will without checking in with customs officials.

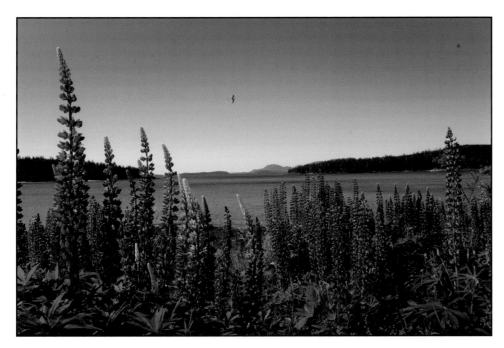

Cadillac Mountain at Acadia National Park is visible from this patch of lupine in Sorrento. Several years ago the National Park Service set out to eradicate the showy purple lupine from Acadia because it's an invasive plant not native to Maine. A public outcry demanded that the lupine be spared.

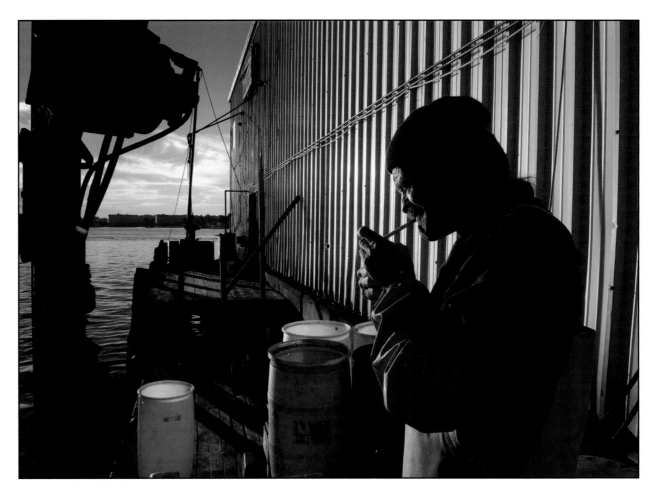

Bait handler Larry Skillins of Portland lights a cigarette between loading lobster boats in Portland harbor at sunrise.

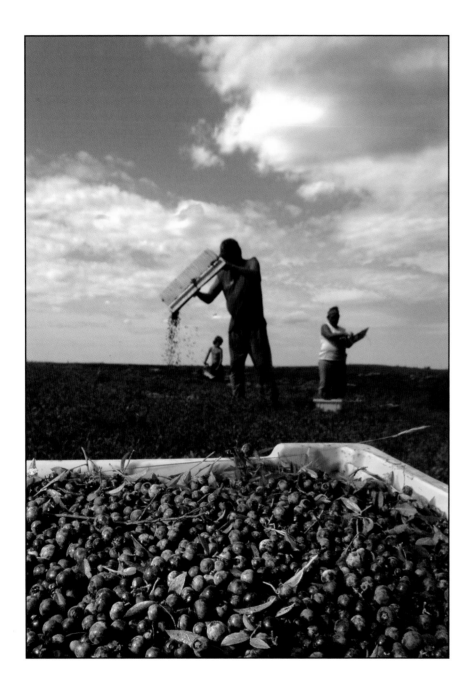

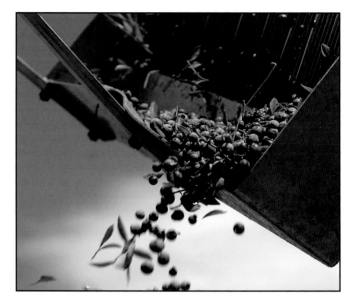

Robert P. Levi, a resident of New Brunswick, helps rake a blueberry field in Township 19MD, Maine. He and many fellow Micmac Indians migrate to Washington County each August to rake blueberries, as their ancestors did. Township 19MD stands for Township 19 Middle Division. It is one of many unorganized townships within the state.

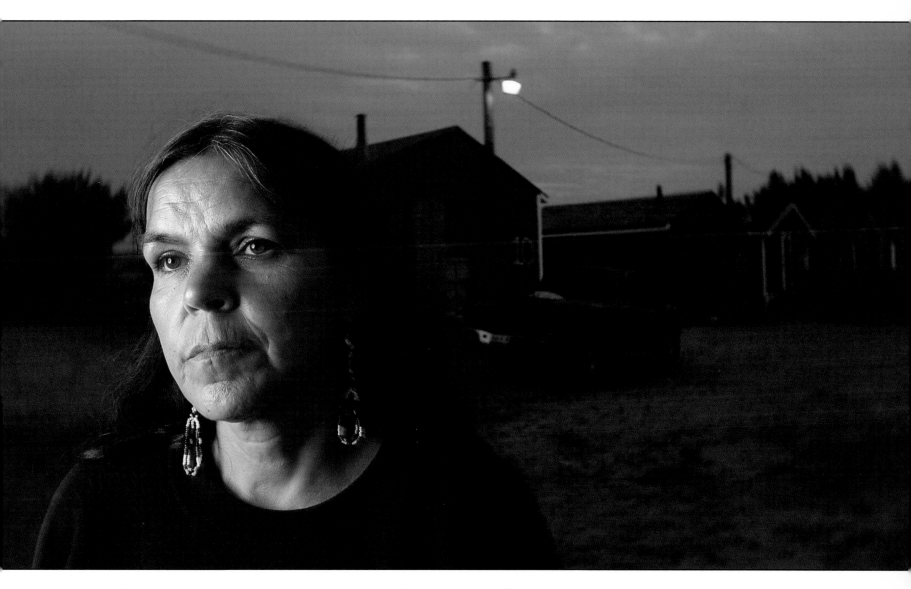

Donna Augustine eagerly awaits the annual blueberry harvest in eastern Maine. Her Micmac forebears have been coming here for the harvest for generations, and Augustine hopes the tradition will continue in the face of increased automation.

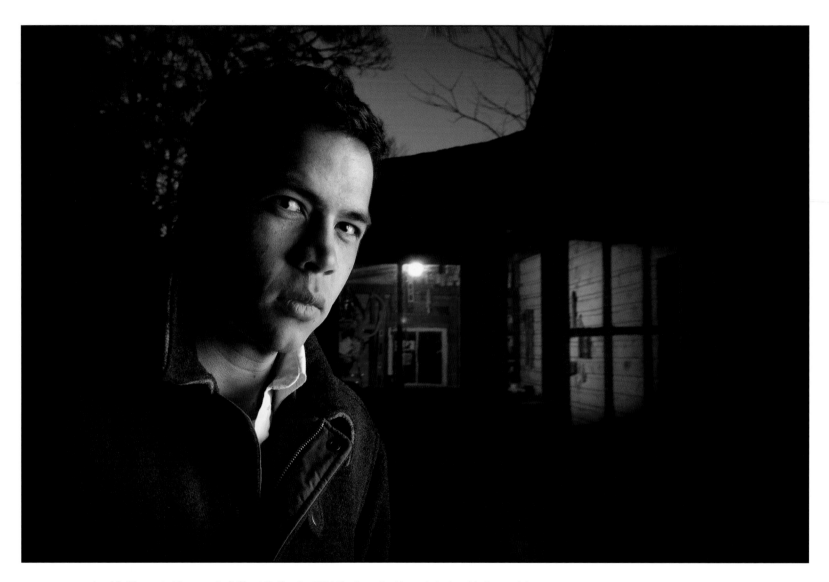

Jaed Coffin wrote his memoir *A Chant To Soothe Wild Elephants* in this tool shed on his Brunswick boyhood property. An acclaimed emerging writer, Coffin bucks the trend of talented young people leaving the state for better opportunities elsewhere.

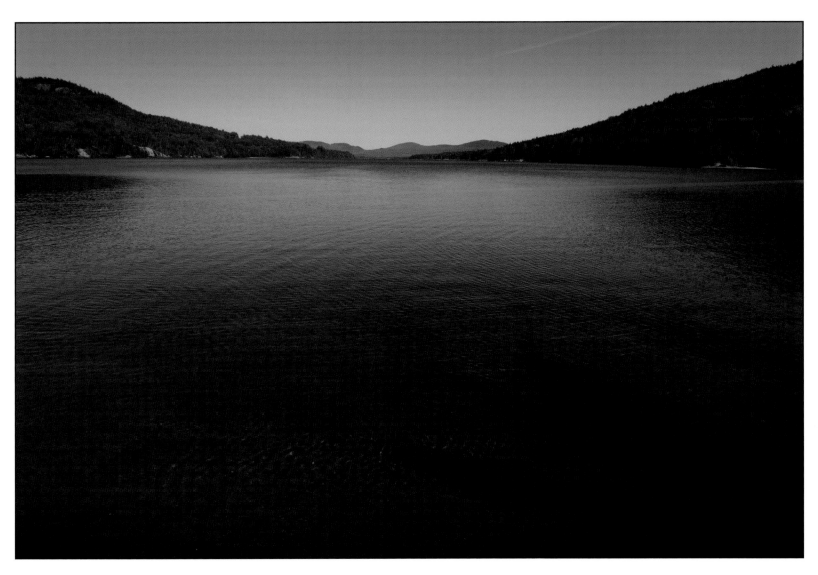

The pristine waters of Attean Pond are a part of the popular thirty-four-mile Moose River bow
trip in Attean Township. Most people complete the trip in three days.

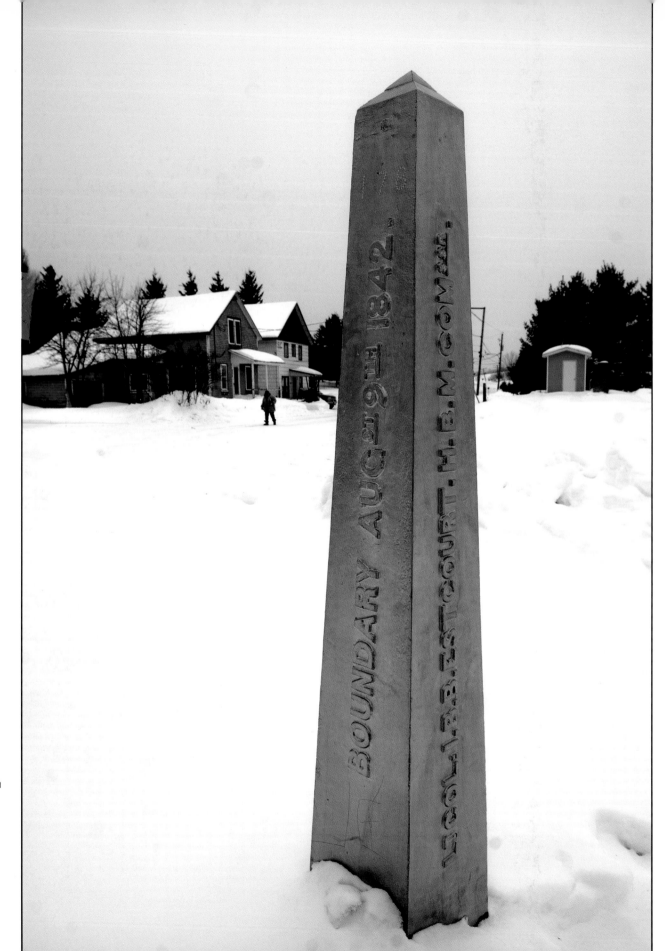

This boundary marker between Maine and Quebec at Estcourt Station marks the northernmost point in Maine and New England.

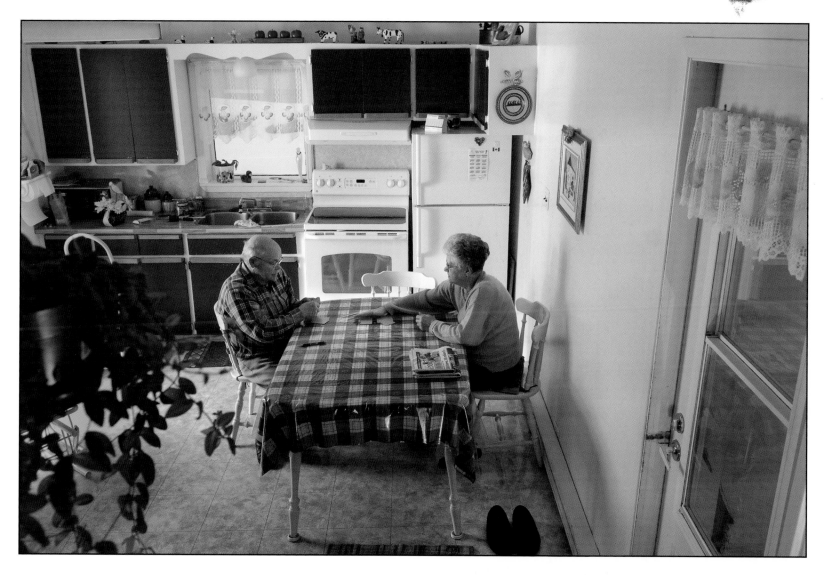

Germaine Ouellet and her husband, Edmond Levesque (above), enjoy an international poker game, as the U.S.-Canada border runs through the kitchen table of their home. She is seated in Estcourt Station, Maine; he is across the border in Quebec. Guy Leblanc, a Canadian customs agent at Pohenegamook, Quebec (right), stands before his office; just beyond is the Levesque-Ouellet home on the border in Estcourt Station, Maine. The population of the Maine town is 10, that of Pohenegamook 3,097. "They're part of the town," says Leblanc of his American neighbors. "We don't really think of them as being in another country. It's part of Maine but it's so small the people living there have to live in Pohenegamook because they have no services." Leblanc is also mayor of Pohenegamook.

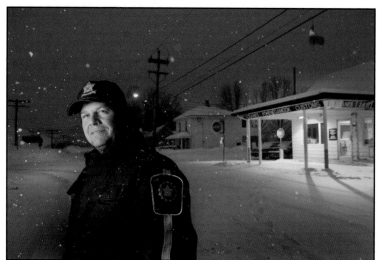

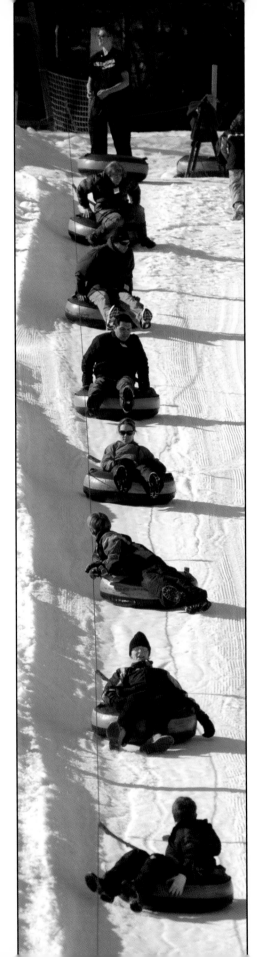

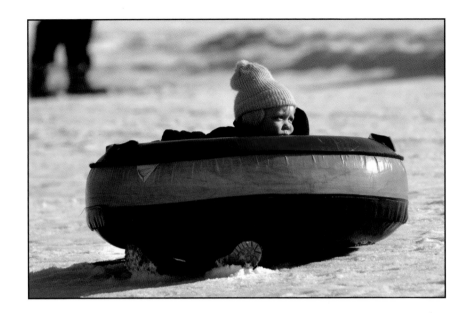

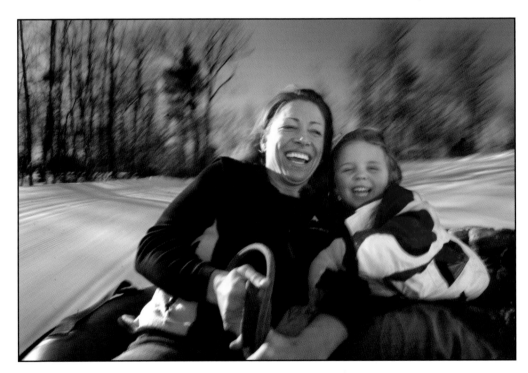

Snow tubers are towed up the hill at Seacoast Snow Park in Windham (left). Michael McGonagle of Pownal, sixteen months (top), can only watch as other family members head up the hill. Michael doesn't meet the minimum height requirement of thirty-six inches. Meanwhile, his mother, Karen, and sister, Calin, watch the world flash past as they barrel downhill. Embracing winter is a key to happiness for year-round residents of Maine, which, the saying goes, has "ten months of winter and two months of damn poor sledding."

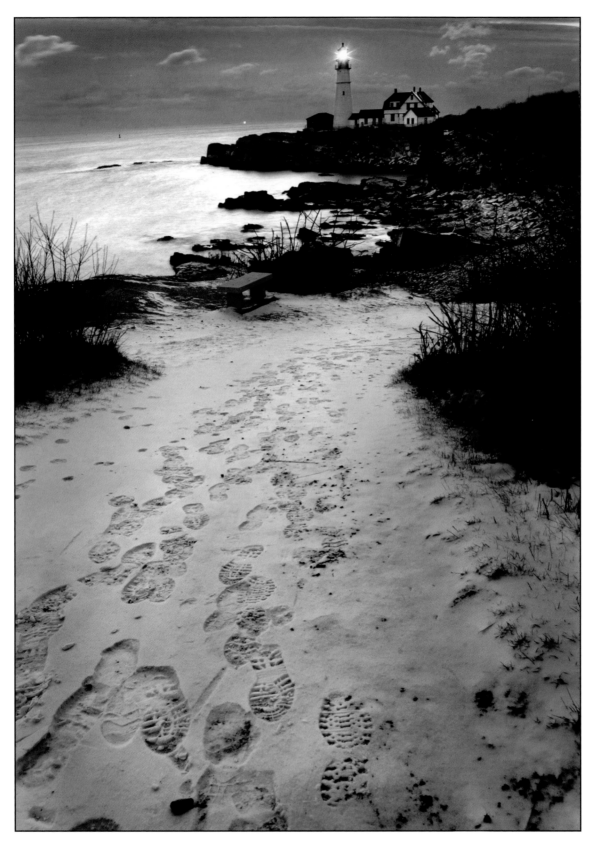

Predawn light gives a bluish cast to a fresh dusting of snow near Portland Head Light in Cape Elizabeth. Built in 1791, commissioned by George Washington, and dedicated by the Marquis de Lafayette, it is the state's oldest lighthouse.

Children in traditional Swedish dress celebrate *midsommar*, an annual observance in northern Aroostook County. In 1870 William Widgery Thomas, Jr., a Maine official, traveled to Sweden to attract settlers to this area that now includes includes Madawaska Lake, New Sweden, Stockholm, Westmanland, and Woodland.

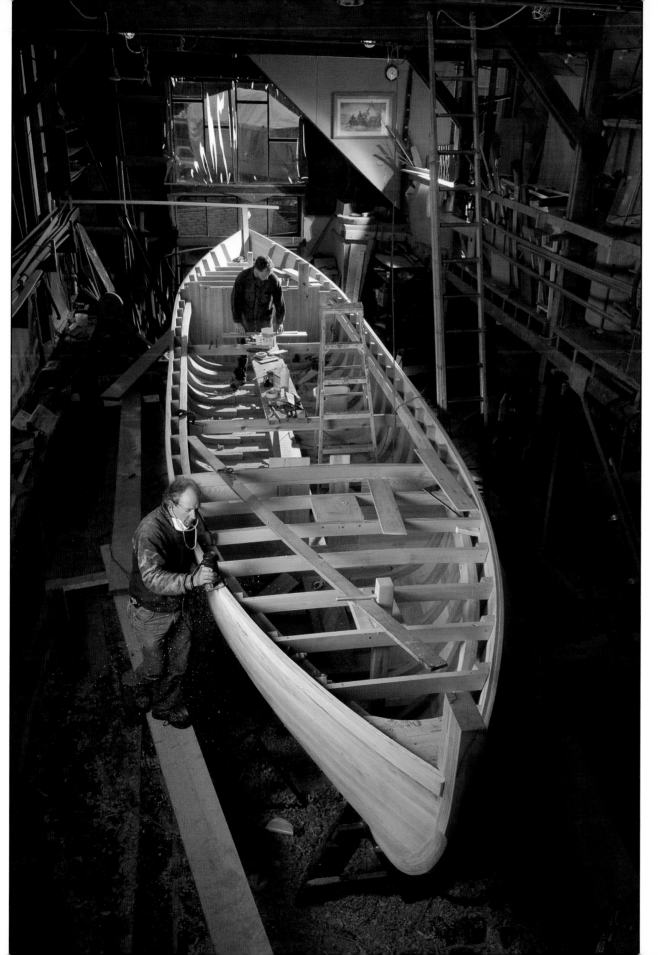

Bob Eger of South Berwick planes a forty-foot Durham boat at Rollins Boatyard in York, while Joe Taylor of Saco works inside the vessel. Sheds like this one are found along much of the coast in a state famous for its boatbuilding.

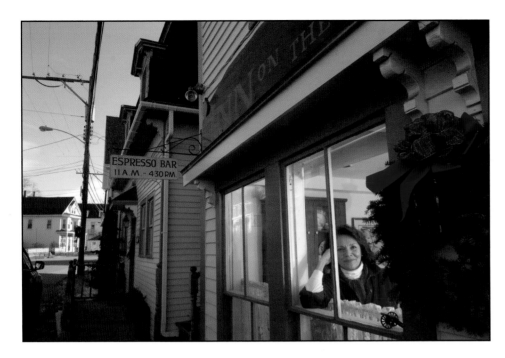

Christina Shipps of Stonington (left) is proprietor of the Inn on the Harbor. A jewelry designer, Shipps says of the coastal town, "It was just the antidote I needed to come back to myself." Ed Hurlburt of Lincolnville (below) gently pulls the nearly completed three-masted square-rigger *Godspeed* in Rockport Harbor. The ship had to be moved briefly so that the foreyard could be attached. Rockport Marine finished work on this reproduction of a three-masted ship that carried English settlers to Jamestown in 1607.

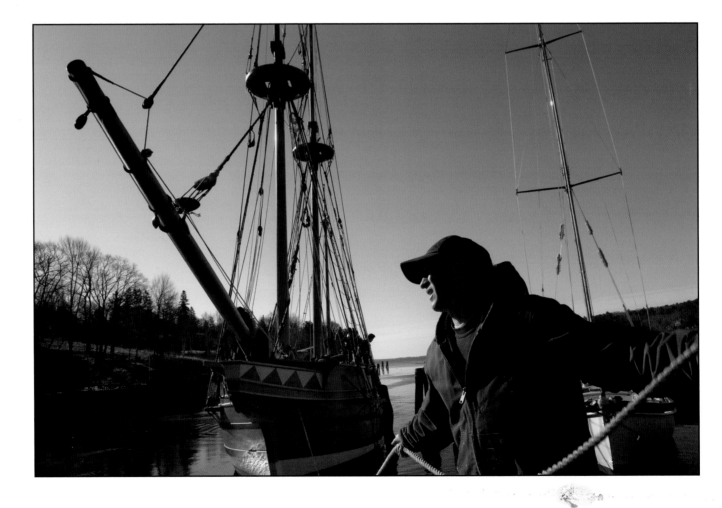

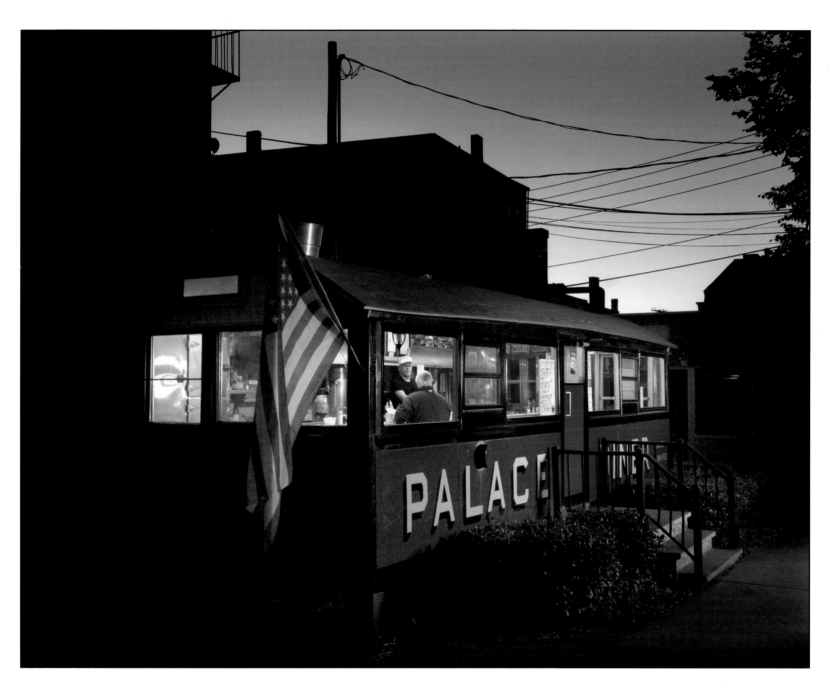

The regulars begin gathering before dawn at the Palace Diner in Biddeford. Maine's oldest diner, the bright red eatery was built in Lowell, Massachusetts, in 1926 and is one of three classic diners left in the state. "We don't have the same menu as in 1926 but it's pretty close," says Kyle Quinn, chatting here with customer Dick Dion.

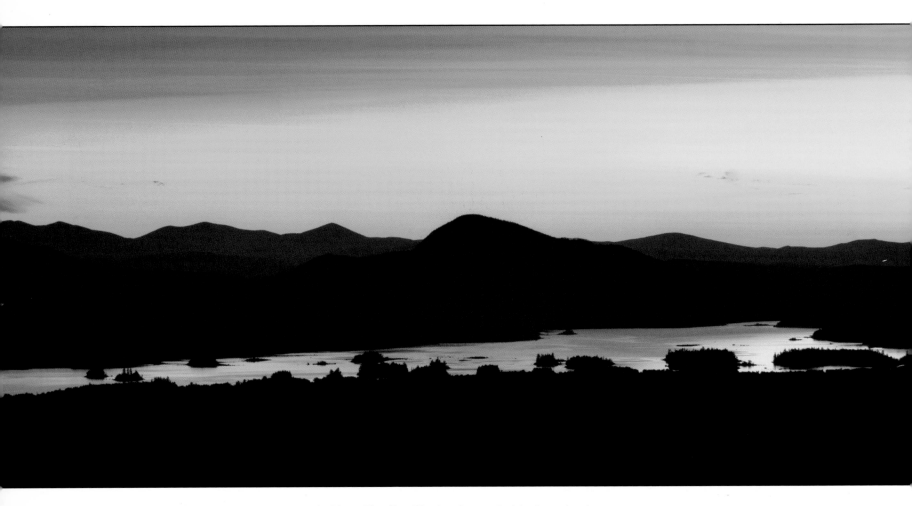

For most canoeists and kayakers doing the Moose River Bow Trip, the adventure both begins and ends on Attean Pond.

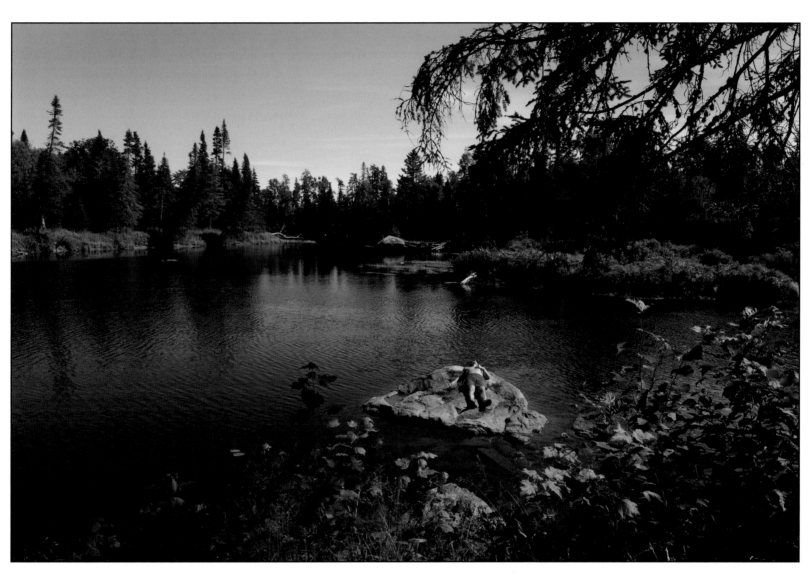

A visitor from Glens Falls, New York, rests in the Moose River in Bradstreet Township as he and his friends near the end of the Moose River bow trip.

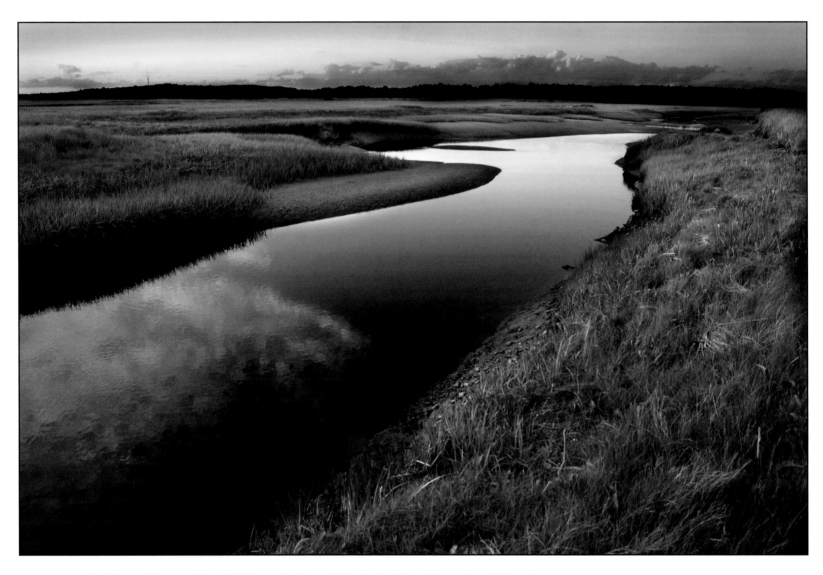

The Dunstan River cuts through 3,100-acre Scarborough Marsh, the habitat of many shore birds and fish. The National Marine Fisheries Service has called the area "essential fish habitat," while the Maine Department of Inland Fisheries and Wildlife notes that 72 percent of Maine's water-dependent bird species can be found here.

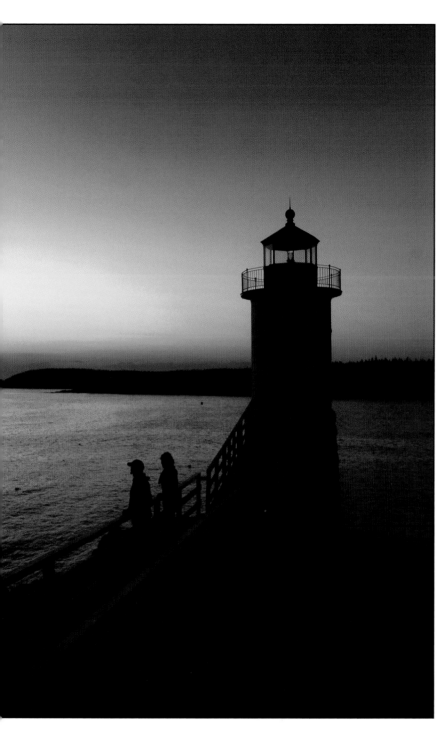

Peter Burke and Robin Tannenbaum of Portland enjoy dusk from the runway at Robinson Point Light on Isle au Haut.

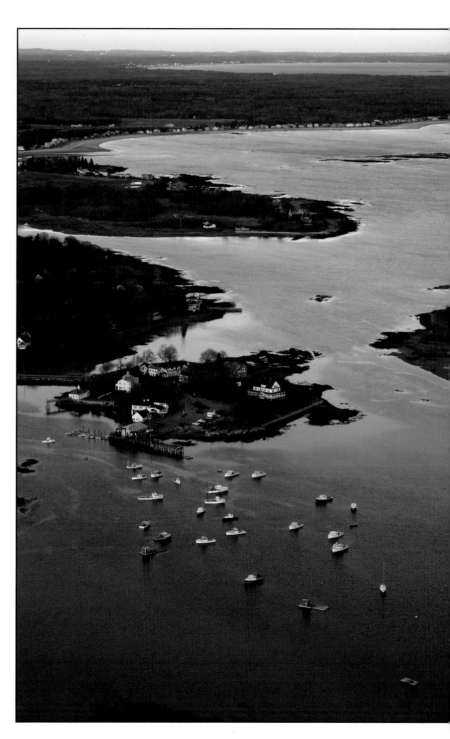

In winter, there are still plenty of lobster boats in the water off Cape Porpoise, though in the harshest weather this area can freeze solid.

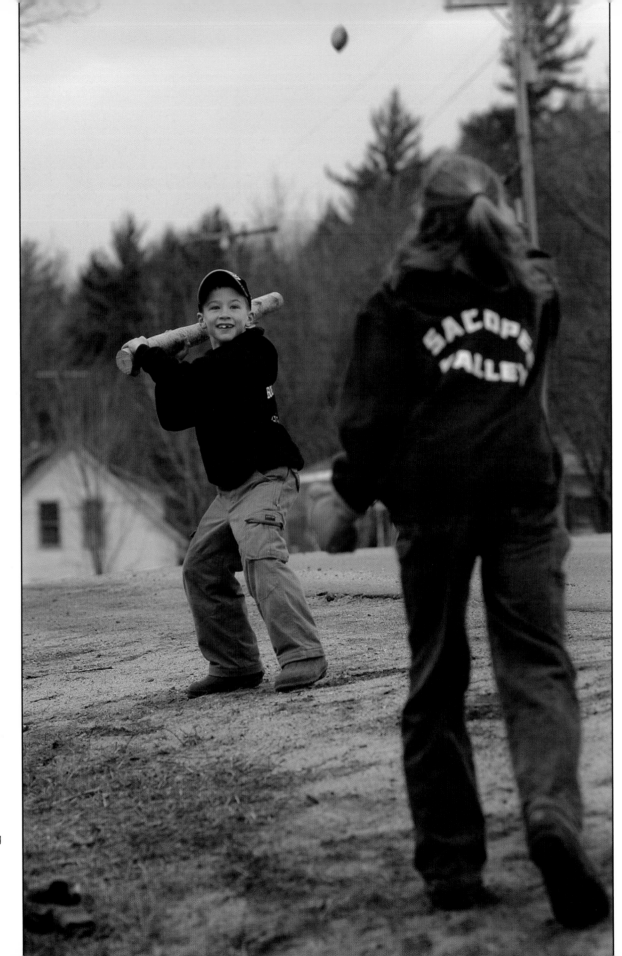

A rock and a stick are all that's needed for a game of baseball after Rhonda Stacey and her cousin Ned Mudgett finish a day's work in the family maple-sugaring business in Parsonsfield.

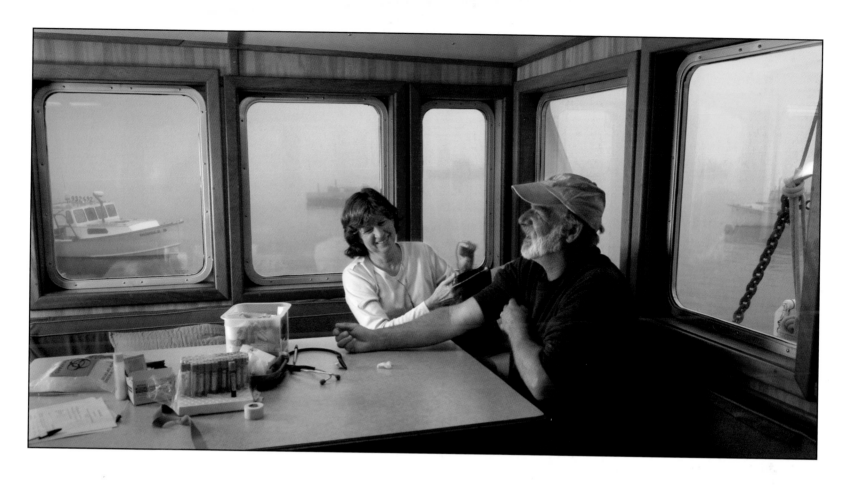

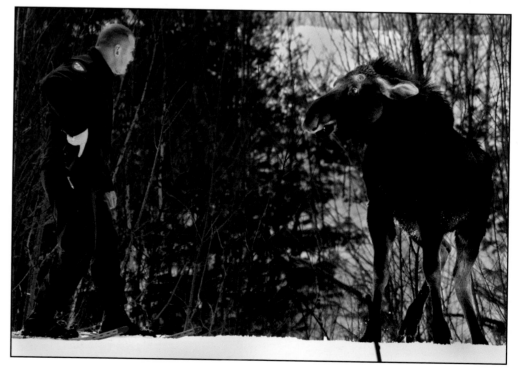

Aboard the *Sunbeam V* (above), nurse Sharon Daley takes the early-morning blood pressure of lobsterman Bill Clark of Isle au Haut. Clark fishes eight hundred traps in his boat visible through the window at left. *Sunbeam V* is a service of the Maine Seacoast Mission Society, bringing a nurse as well as a minister to the aid of people in remote island communities. Responding to a moose complaint in Parsonfield (right), game warden Brian Tripp is ready with his gun as a young four-hundred-pound bull moose lays his ears back, a potential sign of anger. Maine has an estimated moose population of twenty-three thousand.

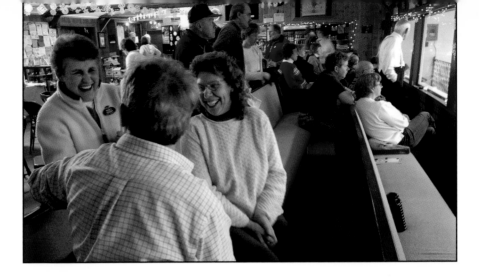

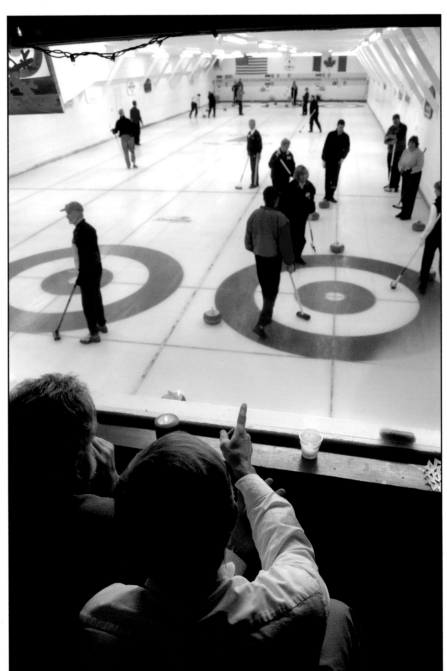

Nancy Hussey of Belfast (left, above) and Lorraine Rickett of Windham share a laugh with Charlie Plaisted of Glen Cove during a tournament at the Belfast Curling Club. Friendship and good sportsmanship are hallmarks of the sport. Belfast Curling Club president Douglas Coffin points (right) as he and Fred Bull take in a curling tournament from the clubroom overlooking the icehouse. Candles on the windowsill reduce fogging of the windows.

A lone cyclist (opposite) moves along Main Street in Fort Fairfield, an Aroostook County town that hosts an annual Maine Potato Blossom Festival in July.

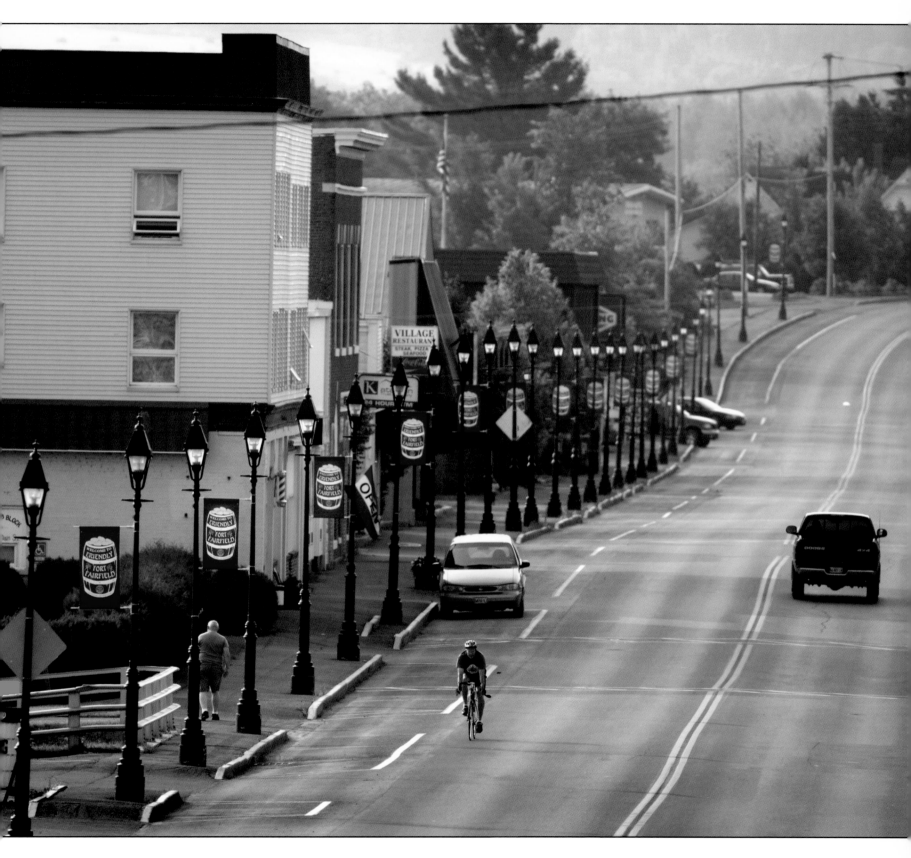

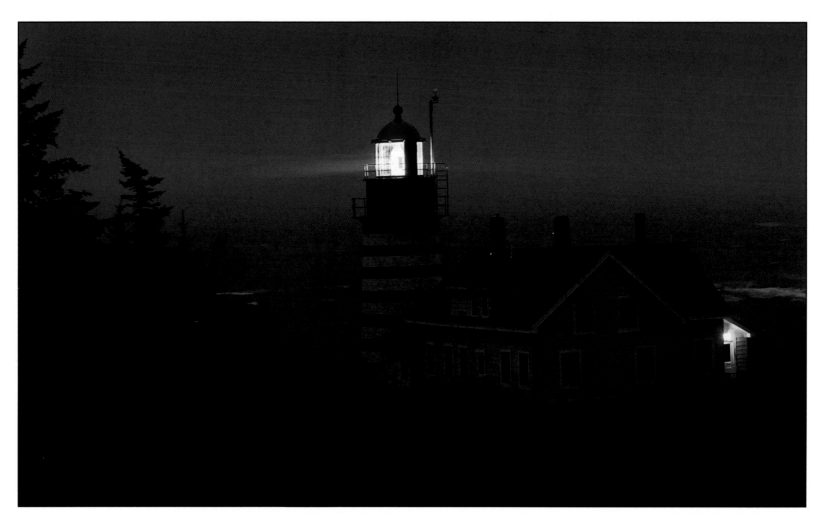

West Quoddy Head Light in Lubec sends out a 30,000-candlepower signal through the fog at dusk. The lighthouse sits on the easternmost point of land in the United States.

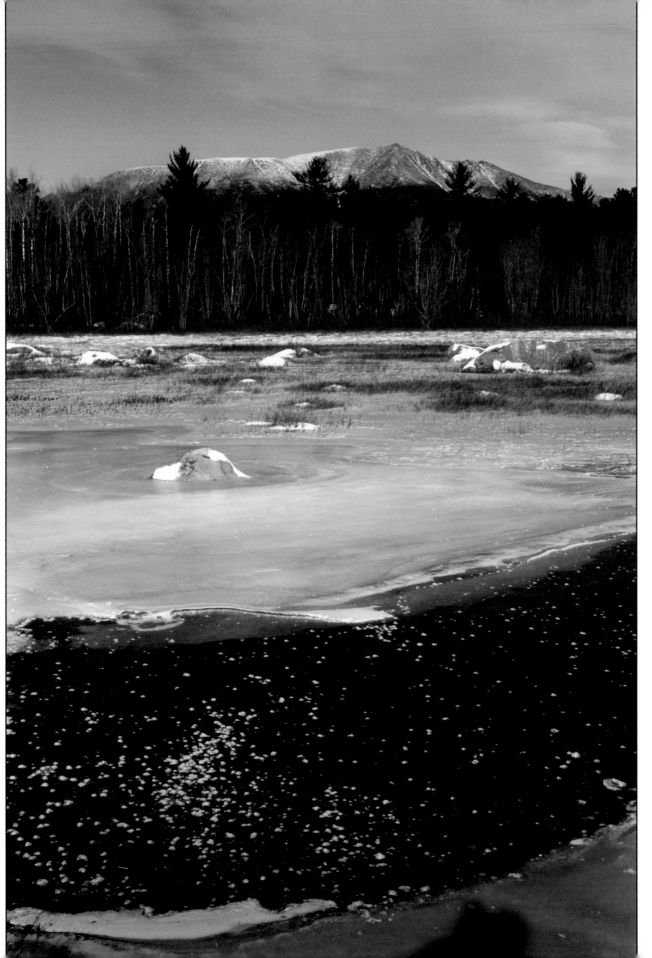

Mt. Katahdin rises beyond this frozen waterway on the legendary Golden Road. As northern terminus of the Appalachian Trail and southern terminus of the International Appalachian Trail, Mount Katahdin is a popular destination. It is Maine's tallest mountain at 5,267 feet and the second highest mountain in New England. Now the centerpiece of Baxter State Park, Katahdin was once buried by glacial ice.

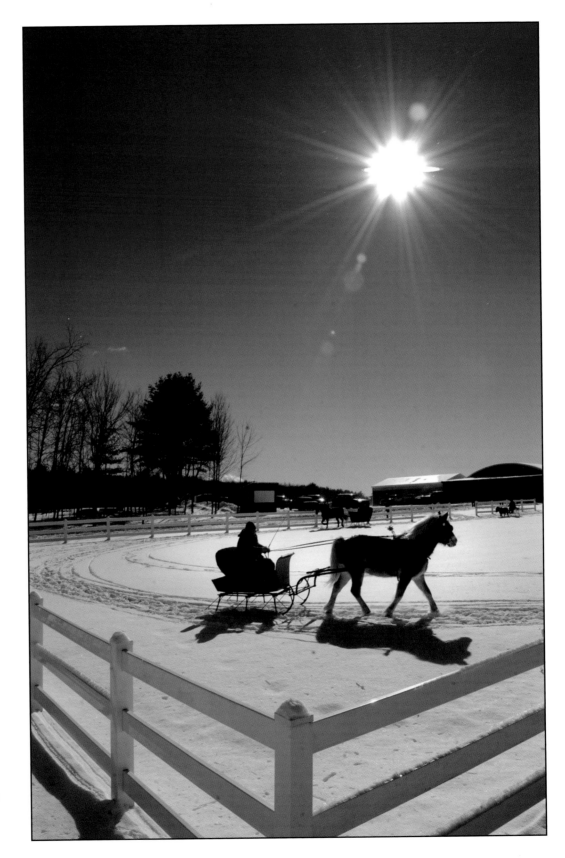

Skyline Farm in North Yarmouth holds an annual sleigh rally and features a year-round antique carriage and sleigh museum.

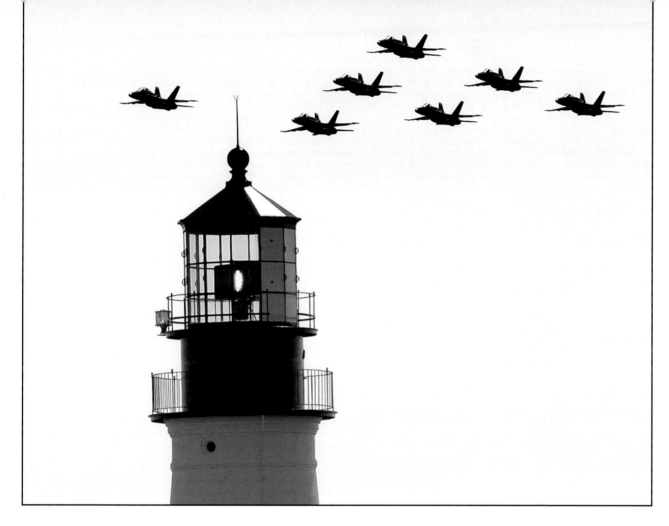

Navy jets rocket past Portland Head Light on Cape Elizabeth before one of the last air shows by the famed aerial team "Blue Angels" at the nearby Brunswick Naval Air Station.

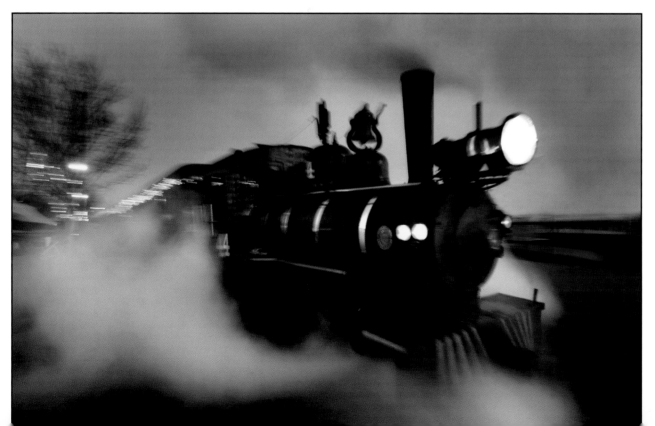

A steam locomotive at the Maine Narrow Gauge Railroad in Portland transports holiday passengers back to an earlier time when these two-foot-gauge steam trains carried lumber, passengers, and farm goods through the state.

55

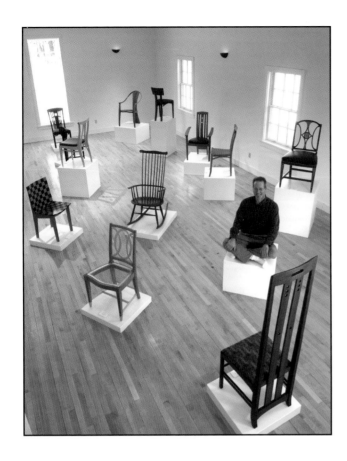

Peter Korn, director of the Center for Furniture Craftsmanship in Rockport (above), sits surrounded by chairs designed and created by some of the most talented woodworkers in America. Colby College student Qiamuddin Amiry (right) speaks gratefully of an improved future, now that the constant danger of growing up in Afghanistan is behind him.

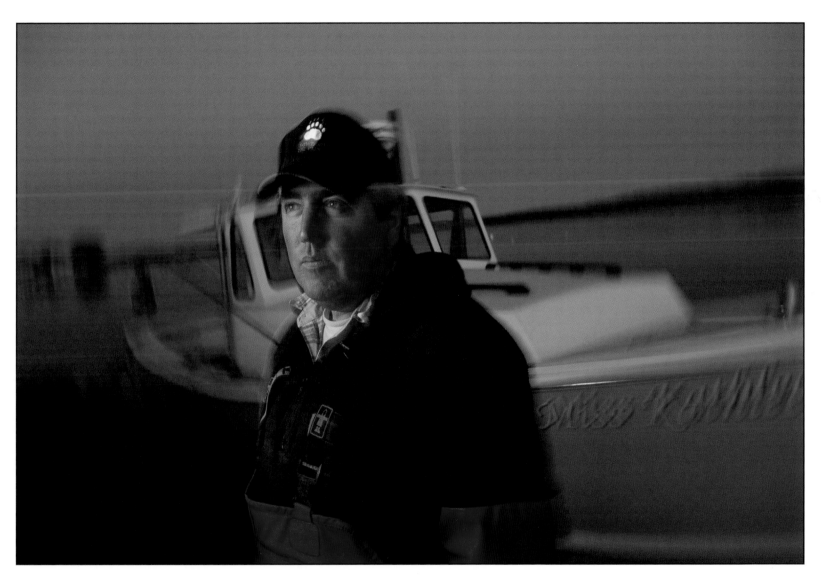

Harpswell Center lobsterman Sheldon Morse heads home from his boat, *Miss Kathleen,*
after a long day of lobstering.

Beach plum roses scent the summer scene in Castine
(right). Lobsterman Charles Leeman and his sternman,
Donny Freeman (below), get underway before dawn at
Mackerel Cove on Bailey Island in Harpswell.

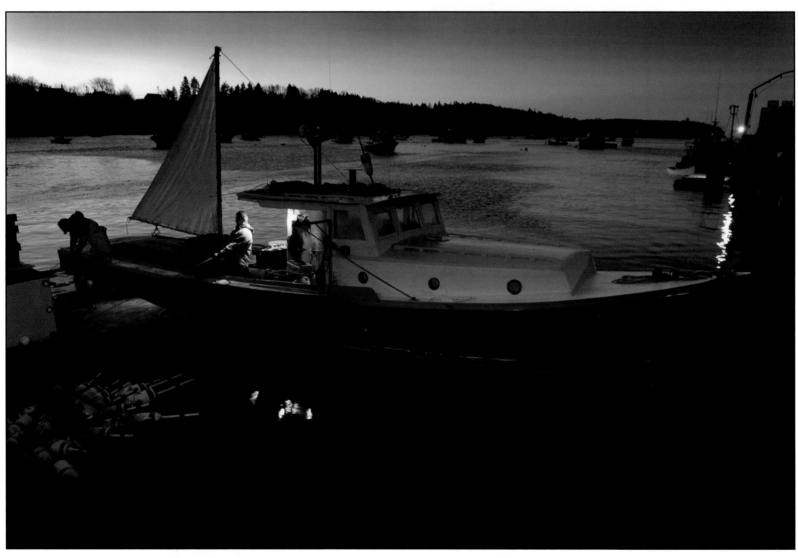

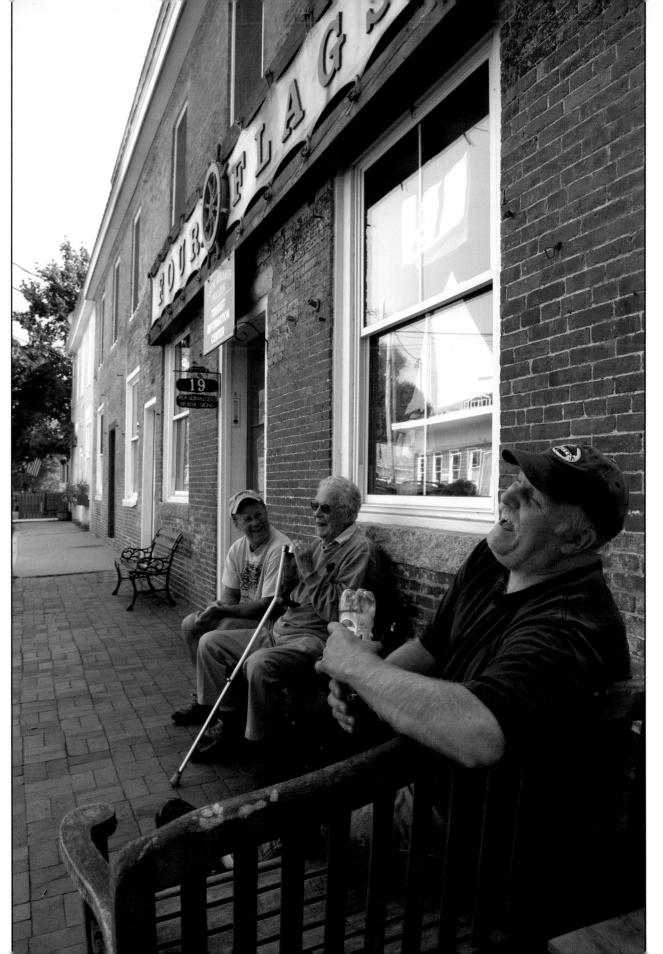

Castine friends share a summer laugh. The town features many historic sites, including eighteenth-century homes and Forts George and Madison.

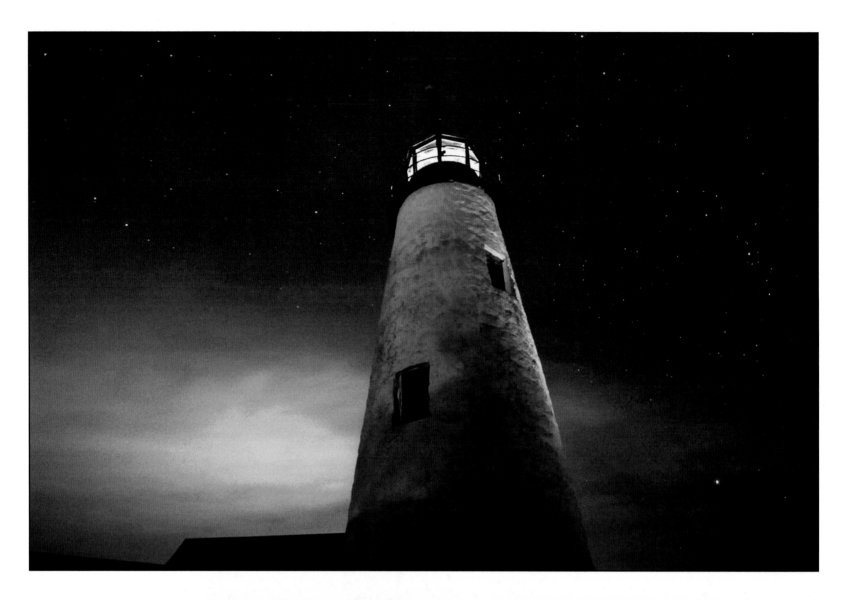

Wood Island Light (above) rises into the night sky off Biddeford. A murder-suicide here in 1896 has led some to believe the site is haunted. Camp counselor Erica Dour (right) practices wakeboarding on the clean, clear waters of Lower Range Pond in Poland. Maine has about three thousand lakes and ponds.

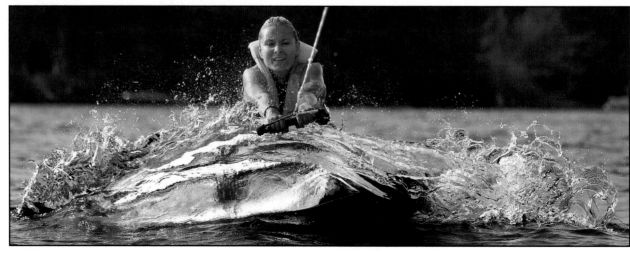

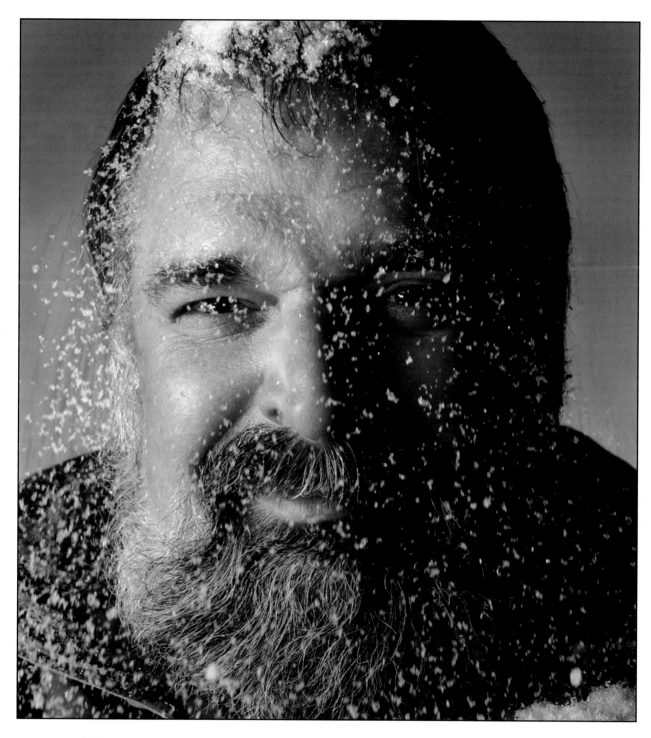

Maine state climatologist Greg Zielinski endures a man-made snowstorm at dusk outside the University of
Maine at Orono. Maine's all-time record temperatures show a remarkable 153-degree swing: The record low of
minus-48 degrees Fahrenheit was set in Van Buren in 1925, while a record high of 105 baked North Bridgton in 1911.

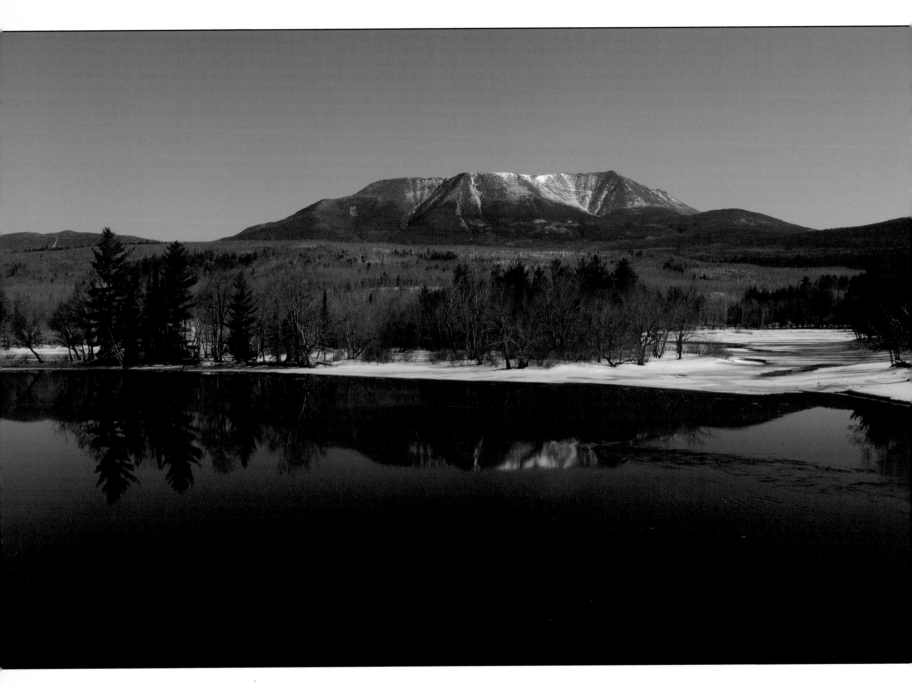

The West Branch of the Penobscot River flows silently past Maine's mightiest mountain, Katahdin (above). The Helon Taylor trail in Baxter State Park (right) is one of the most popular routes up the 5,267-foot mountain. Taylor was an early director of the park.

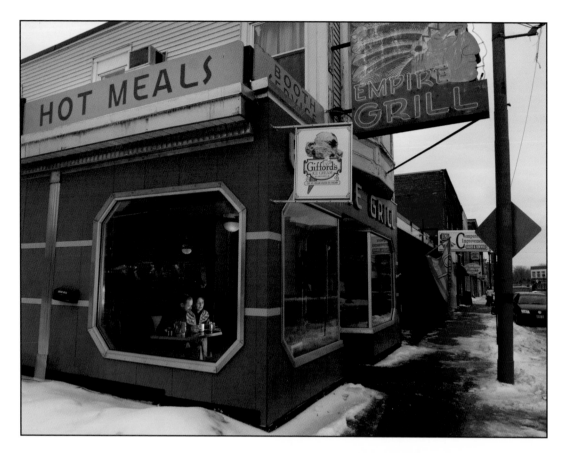

James and Susan Cavanaugh of Wiscasset enjoy a breakfast visit to the Empire Grill in downtown Skowhegan. Much of the film *Empire Falls*, based on Richard Russo's Pulitzer Prize–winning novel, was filmed here in this one-time pizza joint converted to a "classic diner" by movie producers.

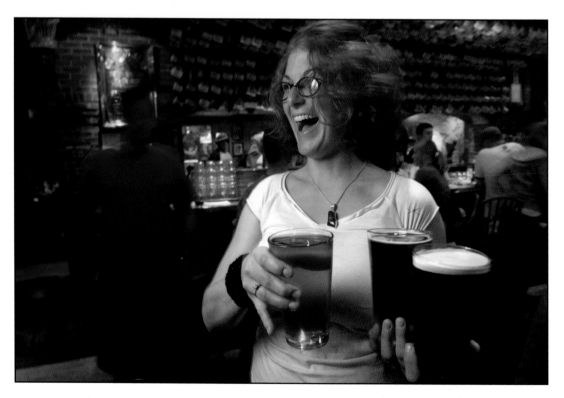

Julie Marquis of Scarborough serves brewpub ales at Gritty McDuff's in Portland's Old Port.

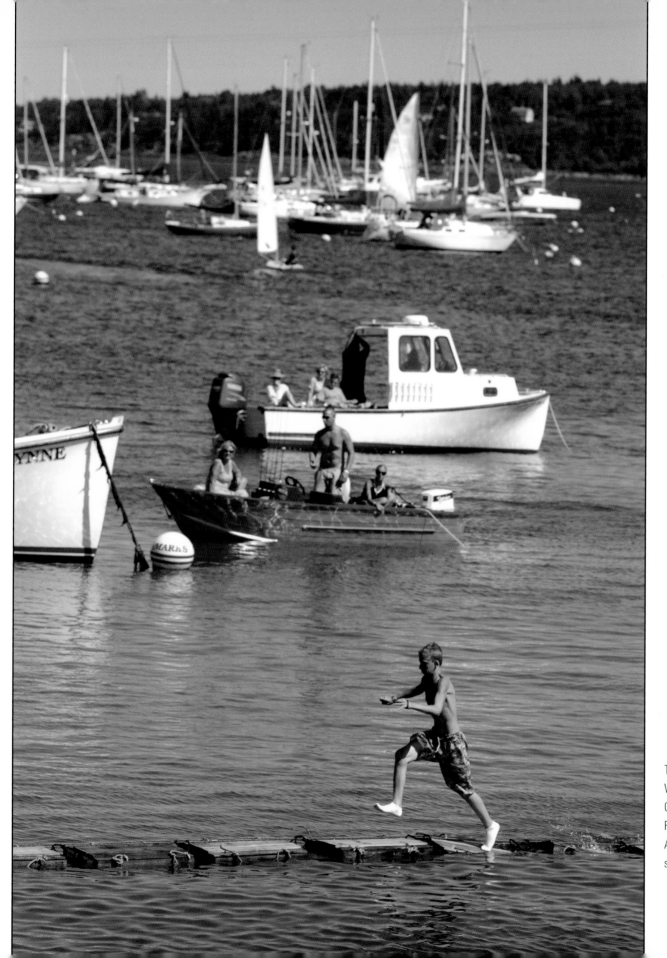

The Great International
William Atwood Lobster
Crate Race is a highlight of
Rockland's Lobster Festival.
About ten tons of lobster are
served at the annual event.

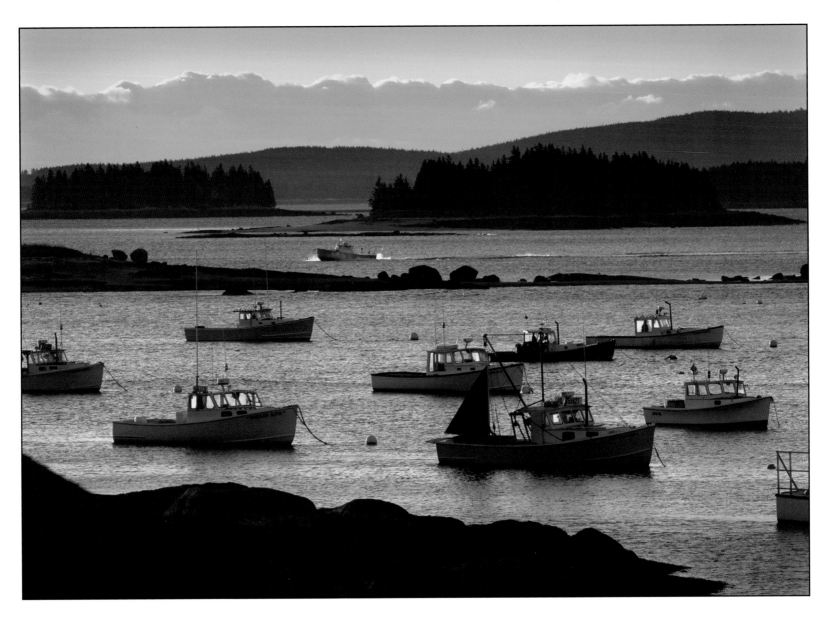

A lobster boat heads for open water in the first rays of morning light while others, bobbing at anchor off Stonington, appear headed in the other direction.

A rolling dock throws a brilliant splash of color across Big Madawaska Lake in Aroostook County.

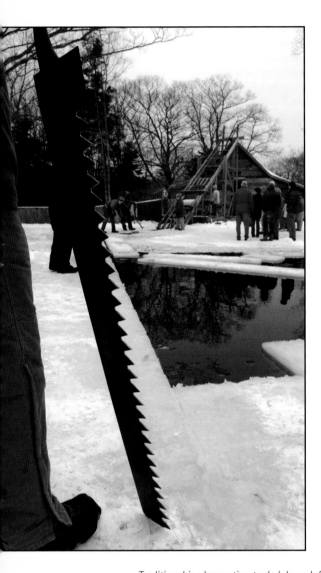

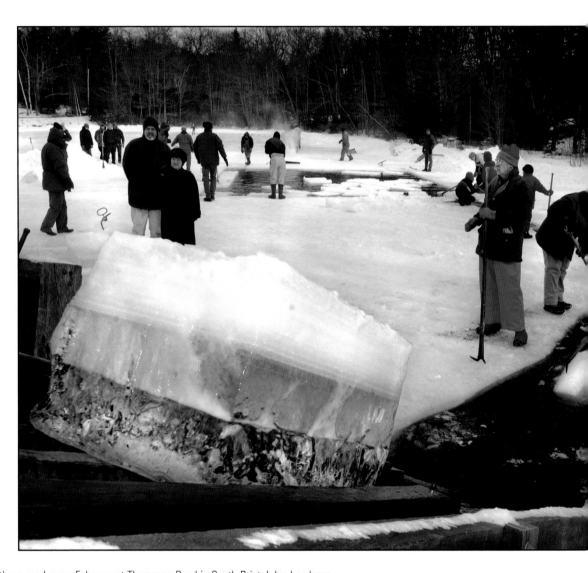

Traditional ice harvesting tools (above left) are used every February at Thompson Pond in South Bristol. Ice has been harvested here since 1826 when Asa Thompson dammed a small brook to make the pond. Maine exported a million tons of ice to southern cities every year in the late nineteenth century. A block hoisted toward Thompson's Ice House (above right) weighs about four hundred pounds and can be over twenty inches thick in the coldest winters.

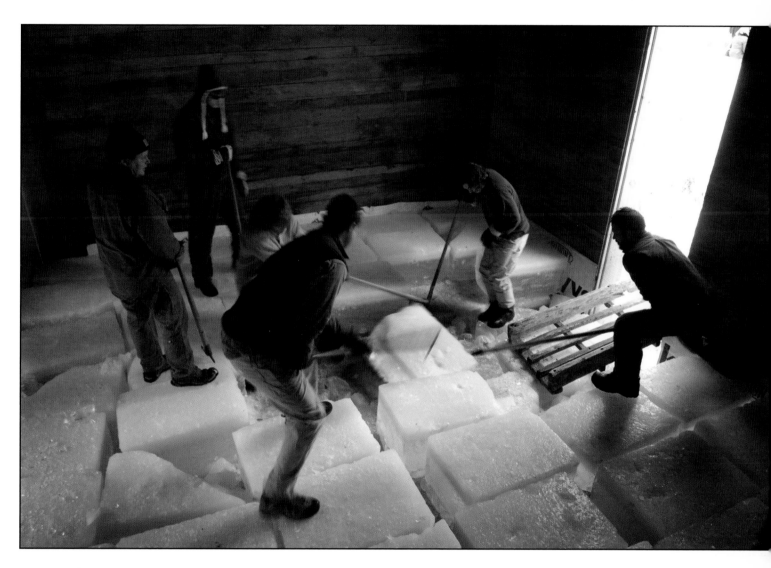

Blocks of ice are maneuvered by a team of volunteers in Thompson's Ice House.

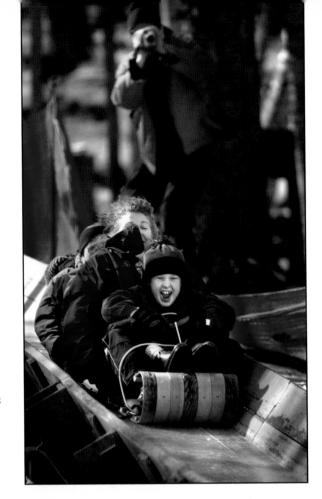

Liam Reading, six, of Bangor (right) speeds down the toboggan chute at the Camden Snowbowl with his mother, Claire Reading, and their friends. With speeds that reach more than 40 mph, things can go awry at the National Toboggan Championships in Camden (below) after tobogganers rocket out of the four-hundred-foot ice-coated chute.

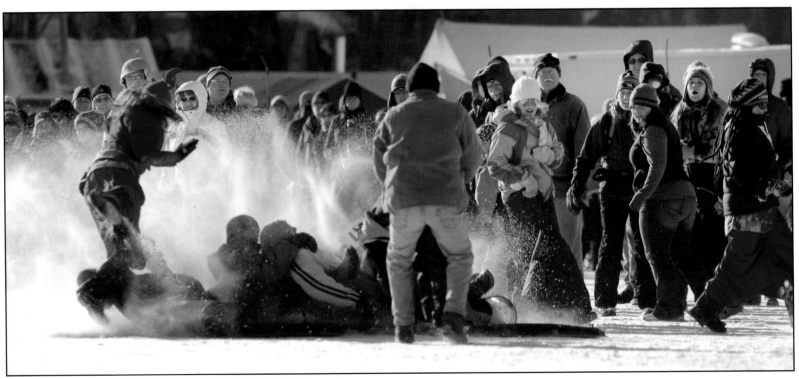

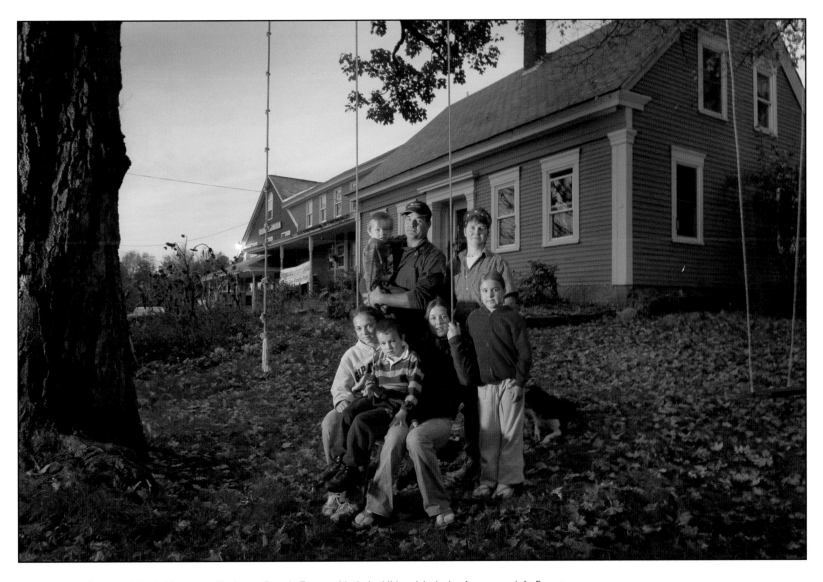

Gregg and Gloria Varney run Nezinscot Farm in Turner with their children (clockwise from upper left, Everet, Mackenzie, Natasha, Roy, and Samantha). The dairy farm has been in the family since Gregg's grandfather G. W. Varney started it, and in 1994 it became Maine's first certified organic dairy farm. A farm store offers variety, including organic meats, milk, cheese from goats and cows, vegetables, herbs, canned goods from the garden, and wool and exotic yarns from the Varneys' own sheep, llamas, and alpacas.

Relatively high humidity on Matinicus, Maine's most remote island, encourages this unusual orange lichen. The distinctive growth is also found in parts of coastal Great Britain and Scandinavia.

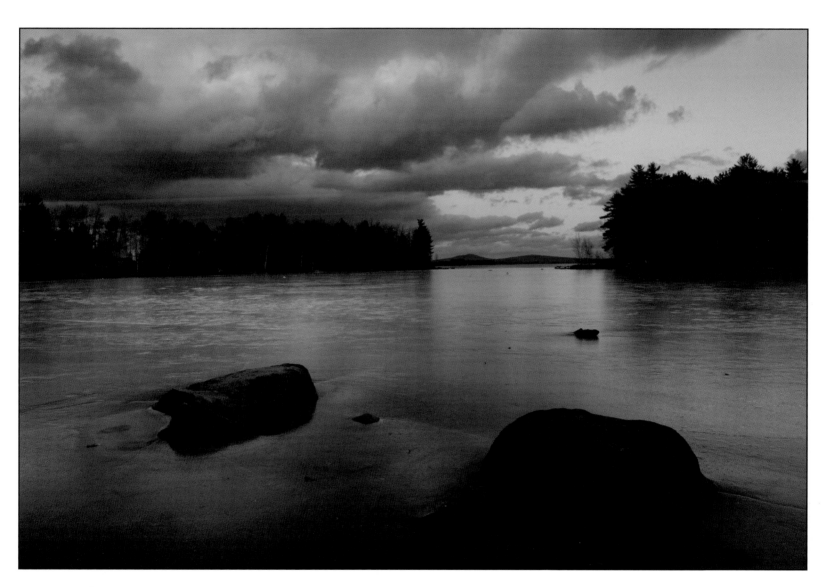

The sun sets over icebound Millinocket Lake on the first day of winter. The nearly nine-thousand-acre lake near Mt. Katahdin contains landlocked salmon, white perch, and lake trout.

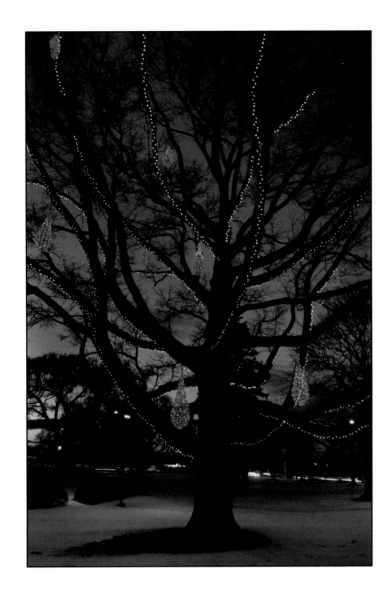

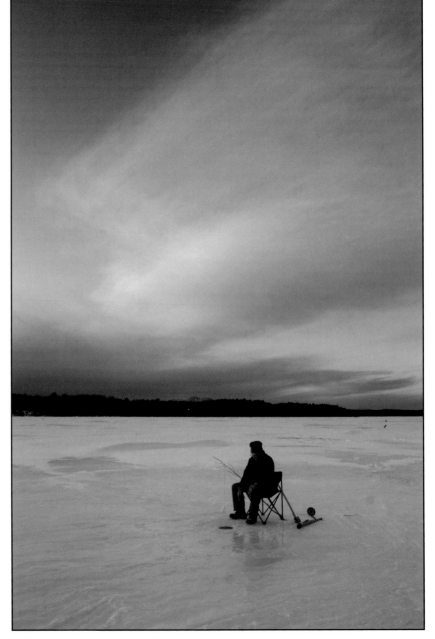

Pandora Lacasse's distinctive winter-holiday handiwork (above) adorns many areas in Portland at year-end. This oak is in Deering Oaks Park. Wilmot "Wiggie" Robinson of Millinocket (right) tries his luck on Dolby Flowage in East Millinocket. Smallmouth bass and white perch are two of the most sought-after fish species found here.

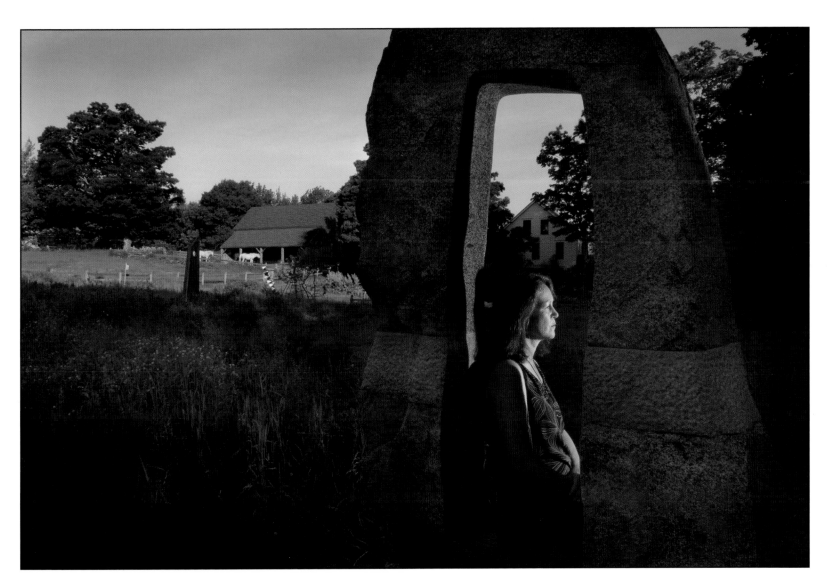

A granite sculpture by Gary Haven Smith called *Reunion* offers a restful spot for June LaCombe at her Hawk Ridge Farm in Pownal. This is one of the many stunning sculptures she displays on her property. For twenty years, the innovative curator-collector has organized sculpture shows across Maine.

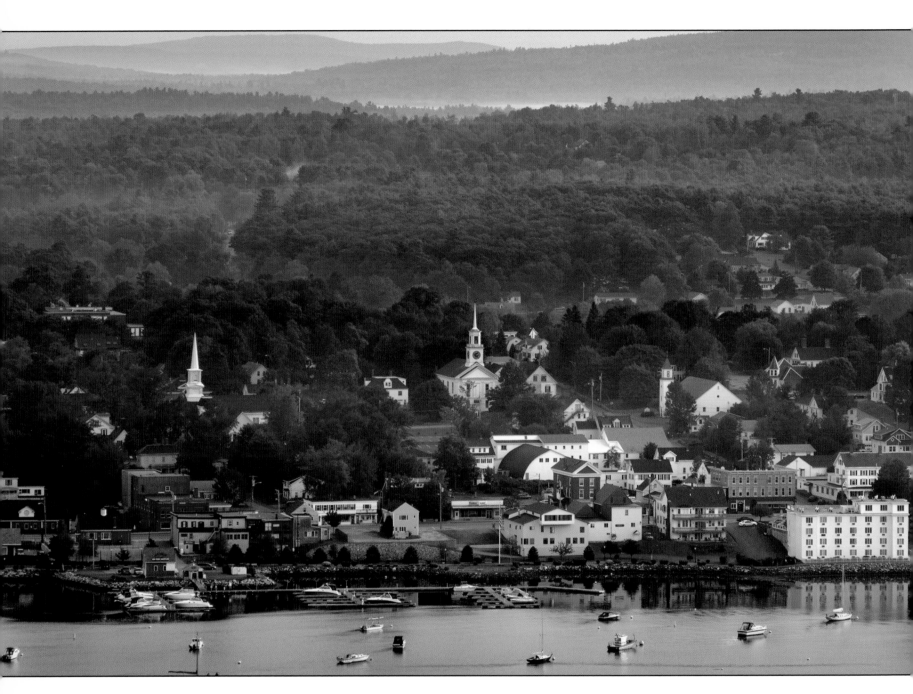

The first rays of morning sun strike a steeple in Bucksport, Maine, in this foggy view from the Penobscot Narrows Bridge observatory, 420 feet above the Penobscot River.

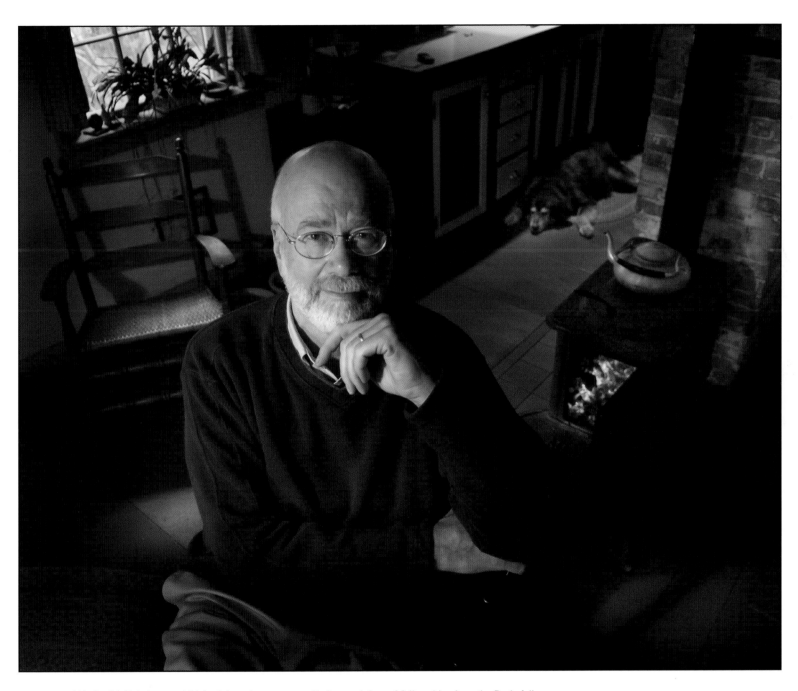

Wesley McNair is one of Maine's best-known poets. He is a recipient of fellowships from the Rockefeller, Fulbright, and Guggenheim foundations; a National Endowment for the Humanities fellowship in literature; two National Endowment for the Arts fellowships for creative writers; and individual artist fellowships in poetry from state arts councils in both Maine and New Hampshire. He lives in Mercer.

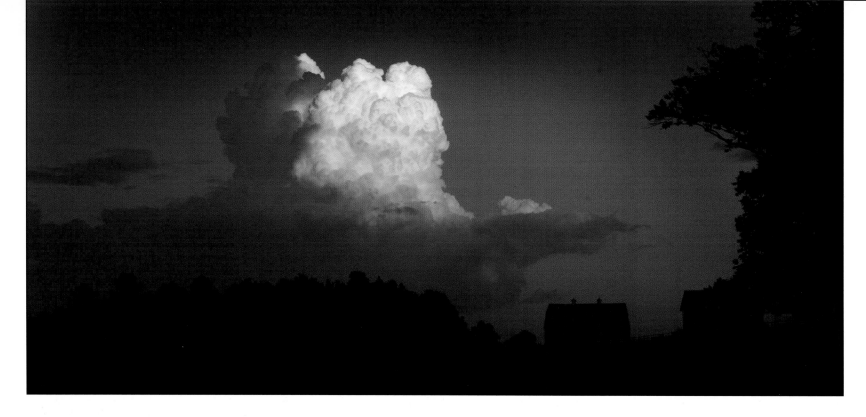
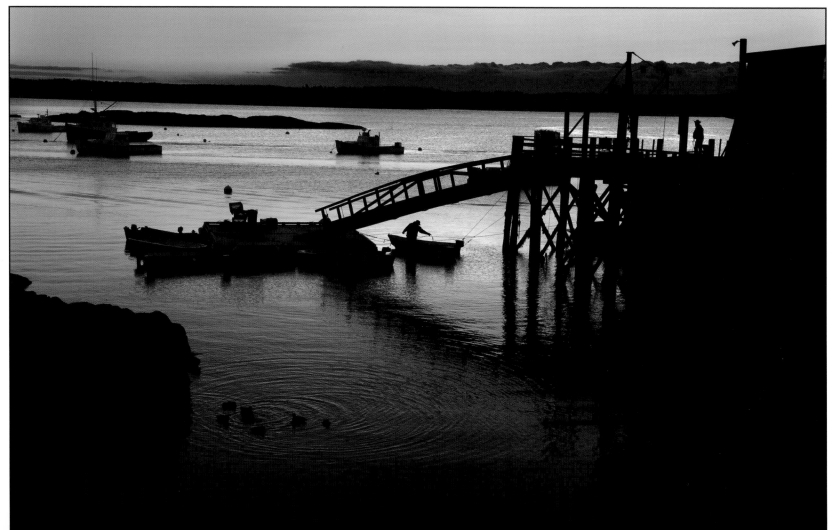

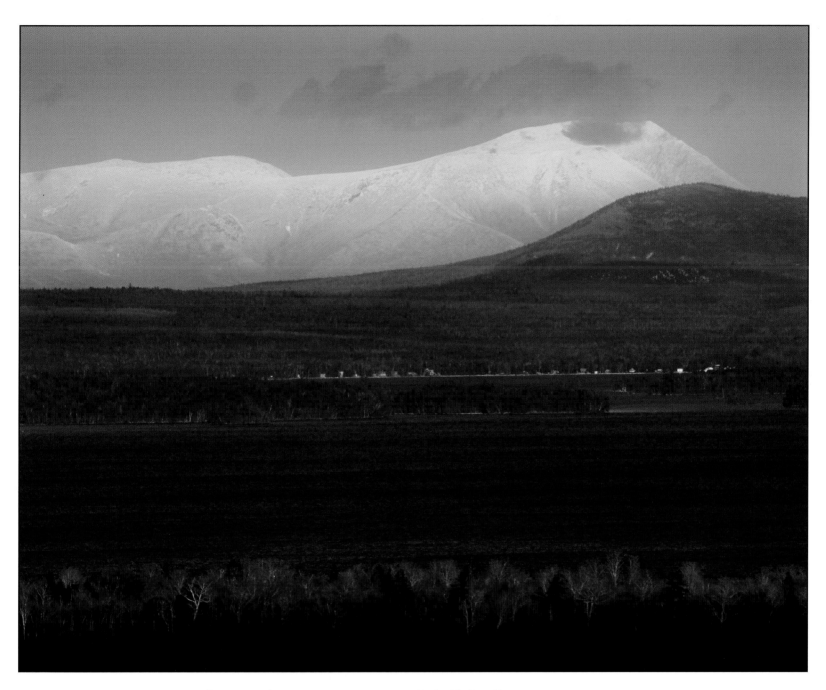

A towering cumulus cloud (opposite, top) floats at dusk beyond a barn at Pineland in New Gloucester. Dawn comes to the Five Islands fishing harbor that is part of Georgetown (opposite, bottom) as a lobsterman unties his skiff. Maine's tallest mountain, Katahdin, rises beyond Moosehead Lake in this view from Big Moose Township.

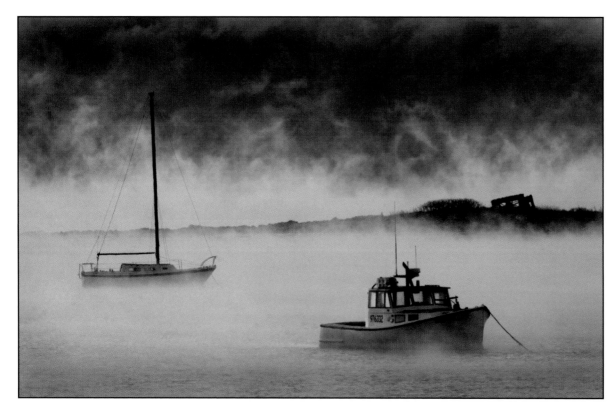

Arctic sea smoke rises from the waters near Cape Porpoise at dawn. The sea smoke only forms when air temperatures of zero degrees Fahrenheit or below interact with relatively warm ocean water.

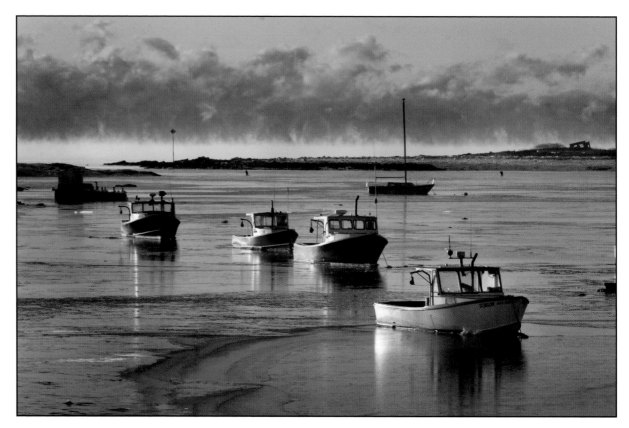

A solid wall of Arctic sea smoke lies beyond Milk Island and these Cape Porpoise boats shortly after a sub-zero sunrise.

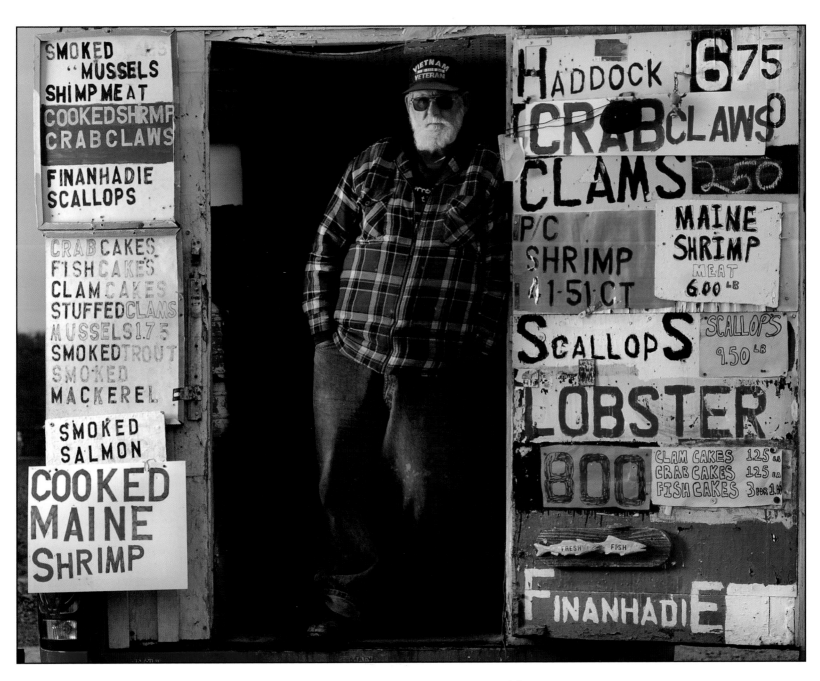

For the past fifteen years Vietnam veteran Alvin Dennison of Owl's Head has been a year-round fixture on Route 1 in Thomaston selling fresh seafood from his pickup truck.

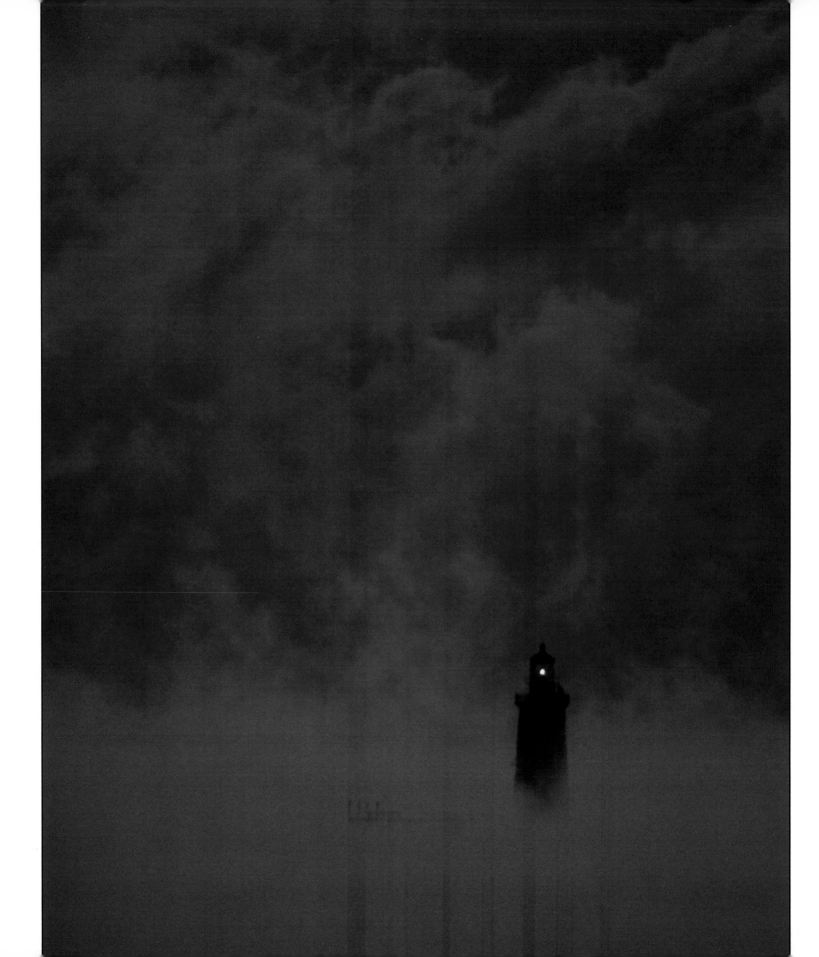

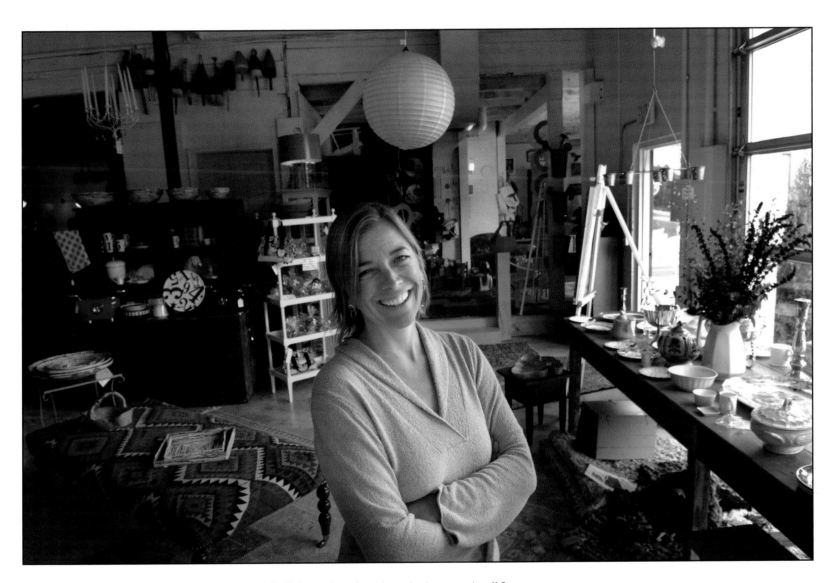

Ram Island Ledge Light, ninety feet tall (left), looms through predawn Arctic sea smoke off Cape Elizabeth. Completed in 1904, the light was originally fired by kerosene. In 1958 the tower was electrified by running an underwater power cable from Portland Head Light. In 2001 the light was converted to solar power. An easy smile from Haley Eberhart of Woolwich (above) greets any visitor to Tintypes, one of many small shops in Bath.

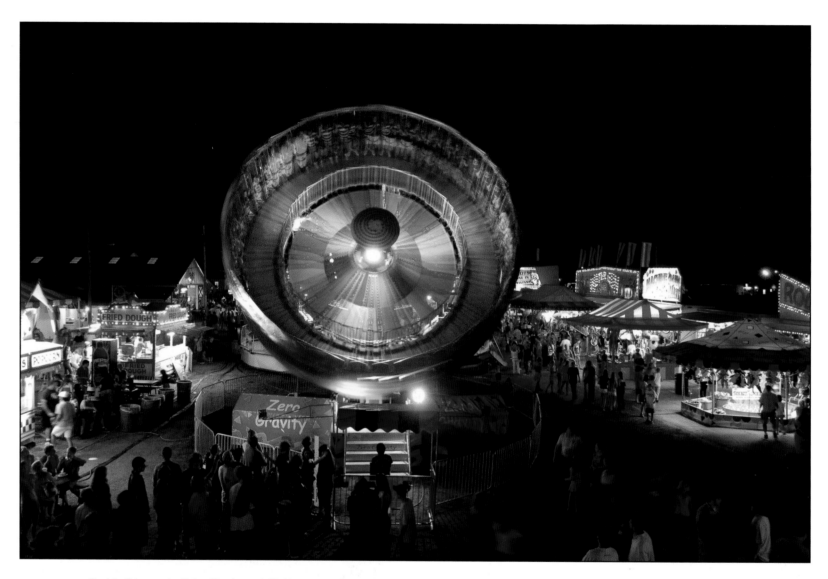

Rapidly firing strobe lights illuminate thrill riders at the Cumberland Fair. The first Cumberland Fair was held in October 1868, but it now bills itself as "always in September." Maine's summer-and-fall fair calendar culminates with the Fryeburg Fair, which runs into early October.

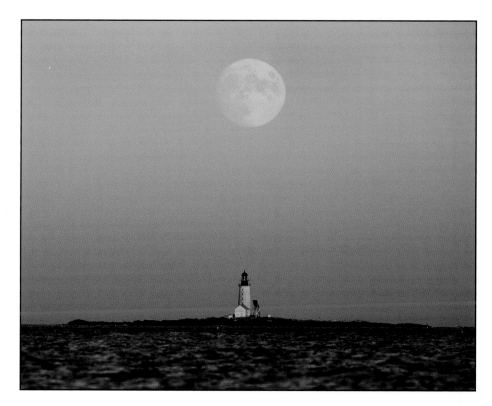

A late-September moon rises above Halfway Rock. The name comes from the island's location about halfway between Cape Elizabeth and Cape Small in Phippsburg. The seventy-six-foot granite tower built in 1871 is similar to Minot's Ledge Light off Cohasset, Massachusetts.

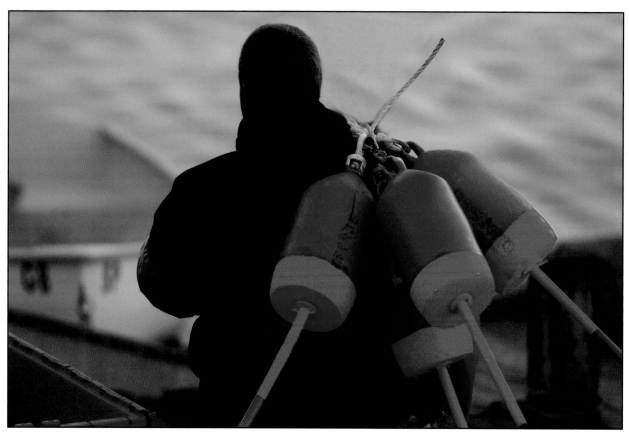

Lobstermen use different color schemes—like this one freshly painted on Frenchboro—to identify their traps.

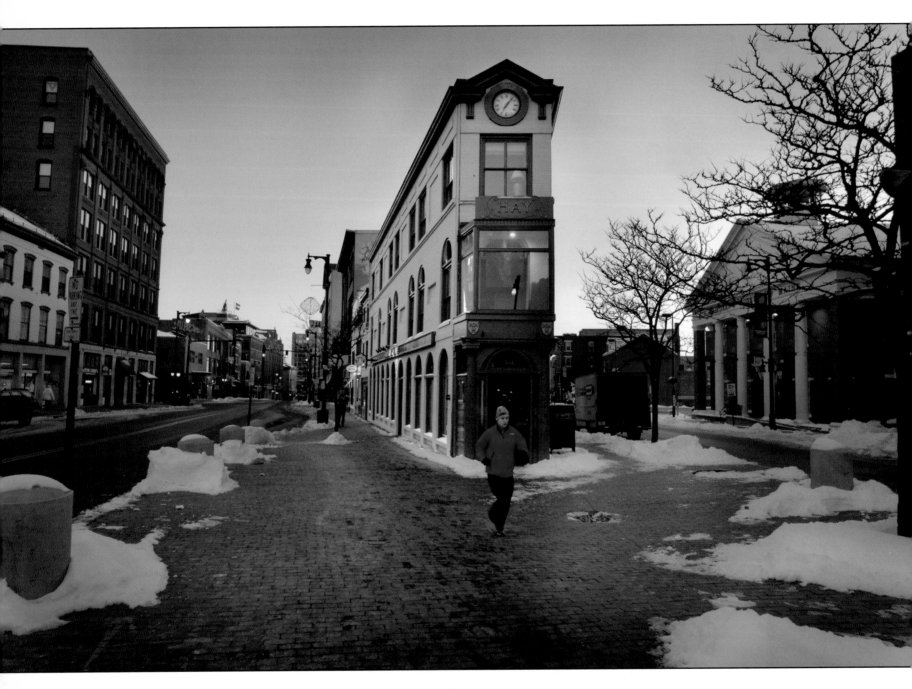

The Hay Building is one of the most distinctive structures in Portland, Maine's largest city.

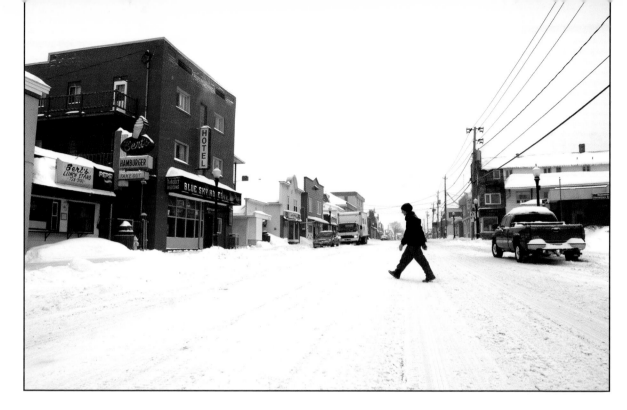

A snowstorm left a fresh white blanket on US Route 1 in Madawaska.

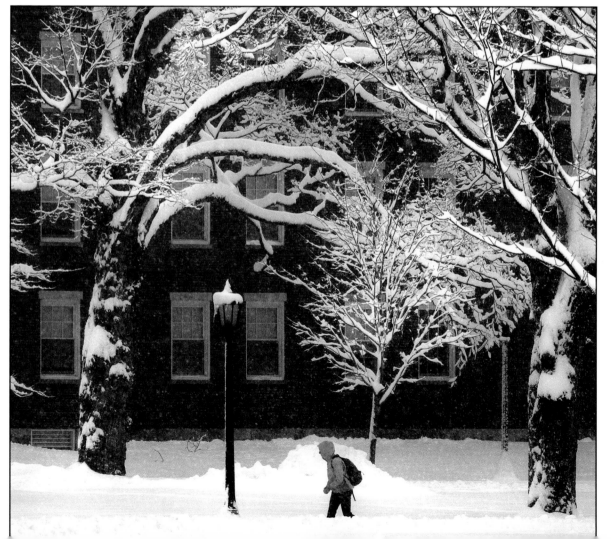

An April storm featuring heavy wet snow coated the campus of Bowdoin College in Brunswick. Bowdoin was founded by Massachusetts governor Samuel Adams in 1794, when Maine was still part of Massachusetts.

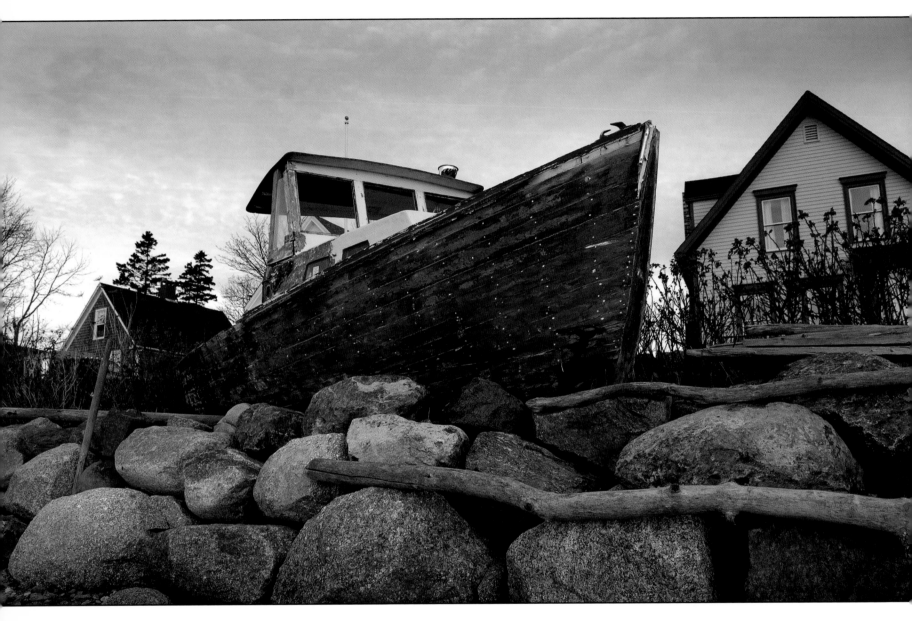

A weathered lobster boat ages by the harbor in Stonington. At the south end of Deer Isle, Stonington is a prolific lobstering town that once had an active granite quarry. Some of its stone was used to build Boston's Museum of Fine Arts.

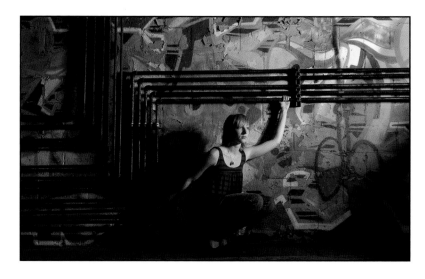

Art student Marika Cowan of Cumberland (left) crouches by a graffiti wall in Portland. A lobster fisherman in Harpswell (below) moves bait to his vessel in preparation for a day on the water.

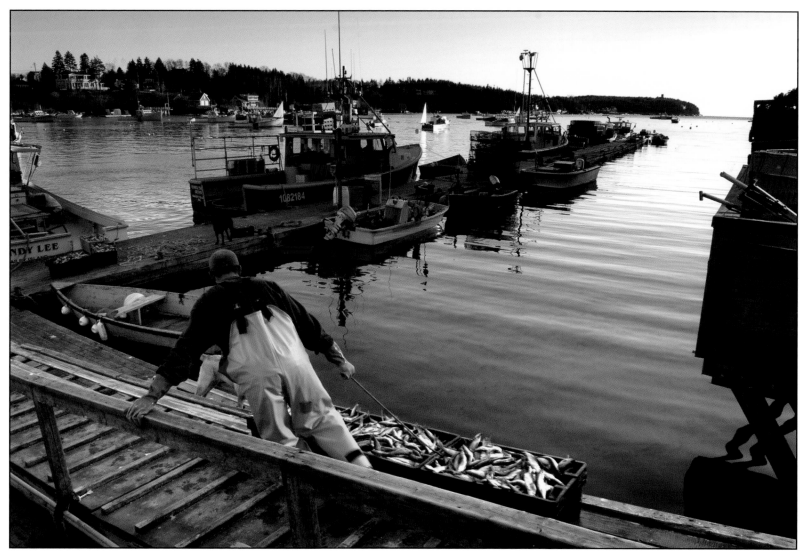

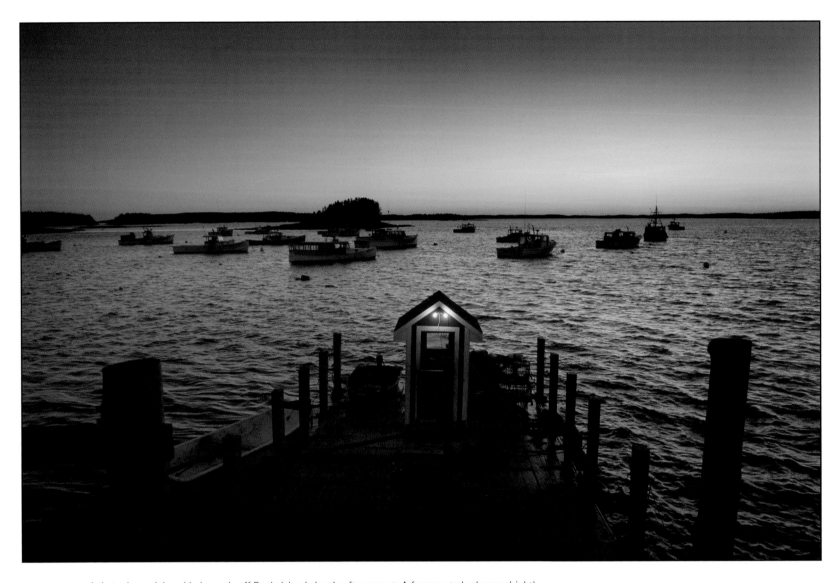

Lobster boats (above) bob gently off Beals Island shortly after sunset. A four-masted schooner (right) glides toward the Rockland breakwater.

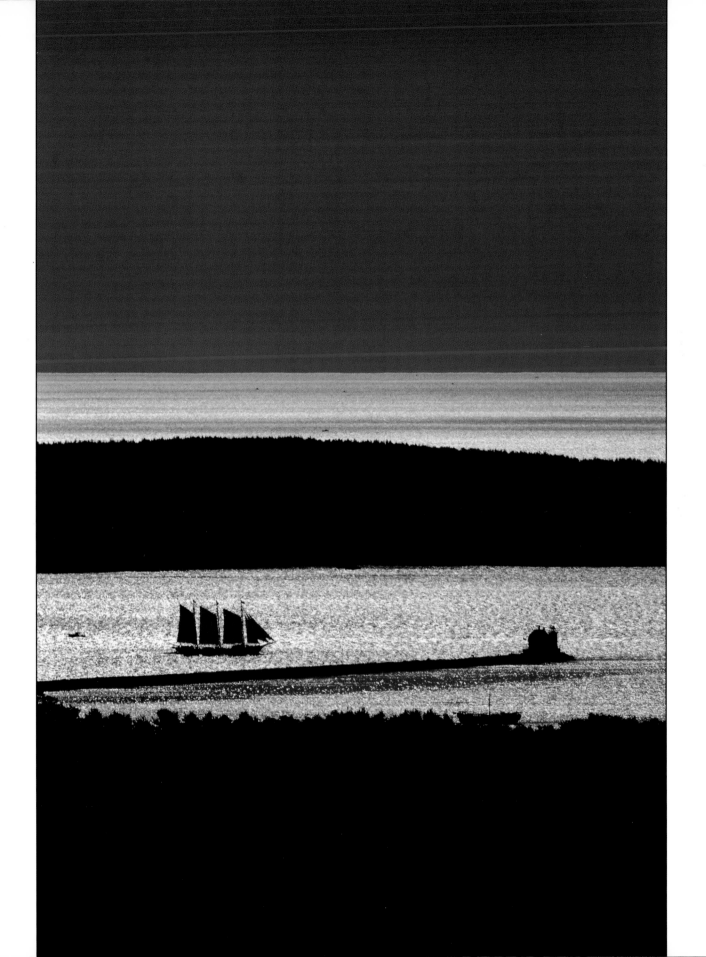

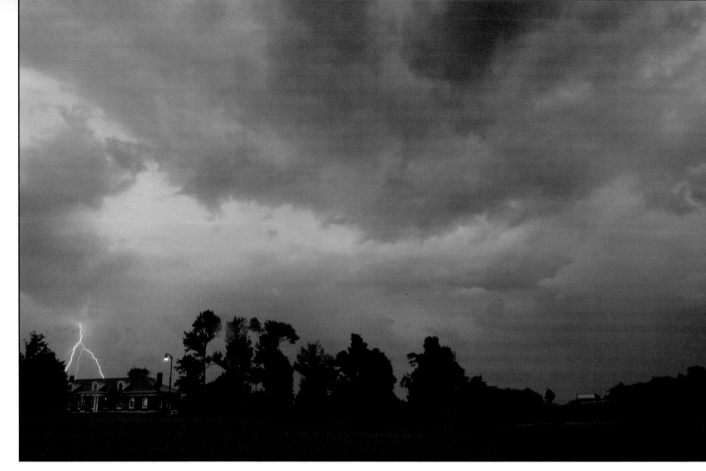

Lightning (right) precedes a July cold front as it approaches the Pineland campus in New Gloucester. Within ten minutes (below) the scene had changed dramatically.

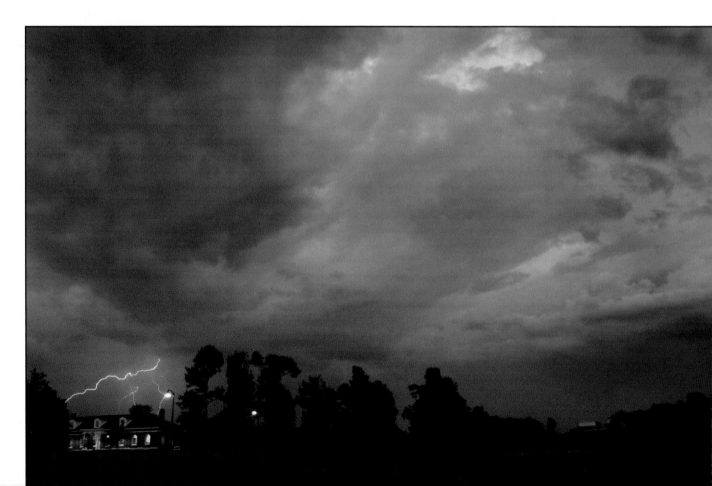

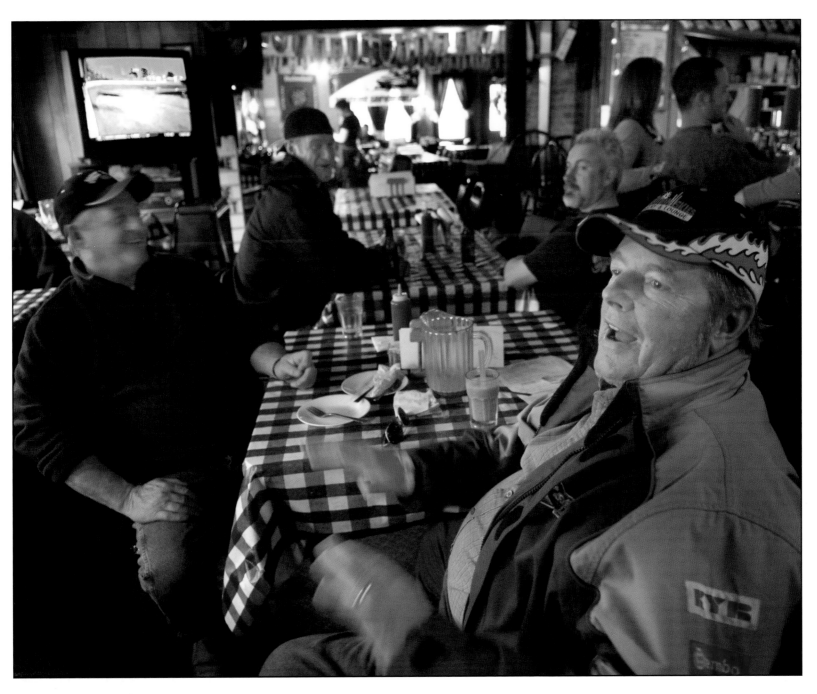

Snowmobilers get together at the Four Season's Cafe in Oquossoc. The Rangeley-Oquossoc area is very popular with snowmobilers from the northeast US and Canada.

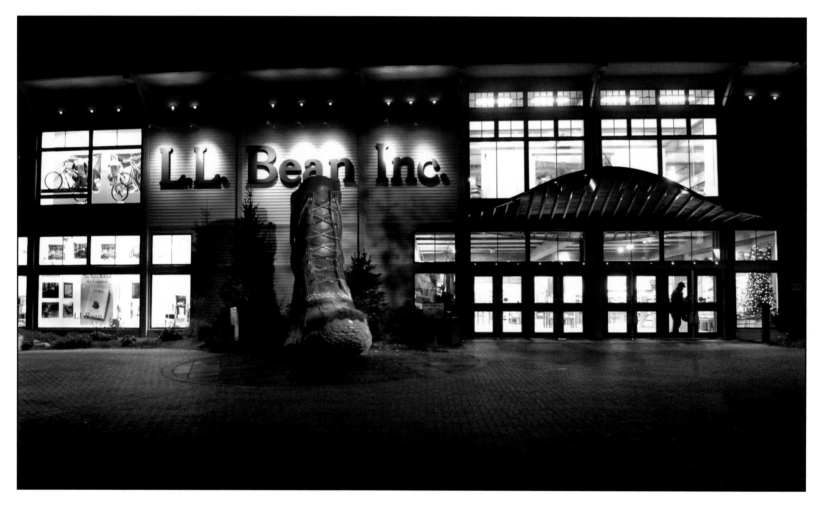

A lone shopper emerges shortly before 3 A.M. from L.L. Bean in Freeport. Founded in 1912 by Leon Leonwood Bean, the company has grown from a one-man operation to a global enterprise with sales of $1.5 billion annually. The store is open 24 hours a day, 365 days a year.

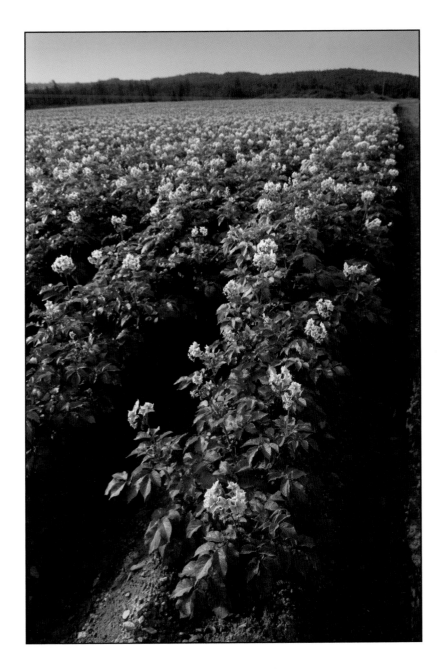

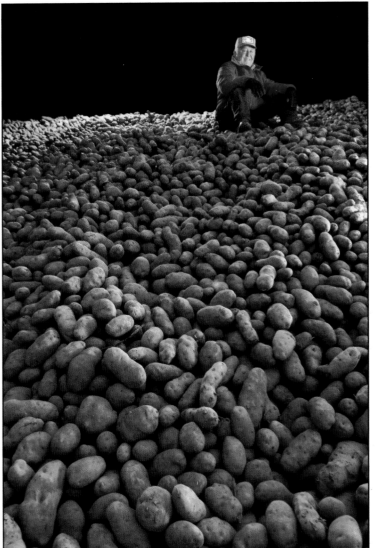

Jerry Flewelling (above) sits atop 3.5 million potatoes stored in one of nine climate-controlled storage barns he and his son maintain at Flewelling Farms in Easton and Fort Fairfield. Millions of these russet burbank potatoes become french fries at restaurants like McDonald's. Potato blossoms (left) are a welcome summer sight in Aroostook County, where the spud is king. Aroostook is the largest county east of the Mississippi.

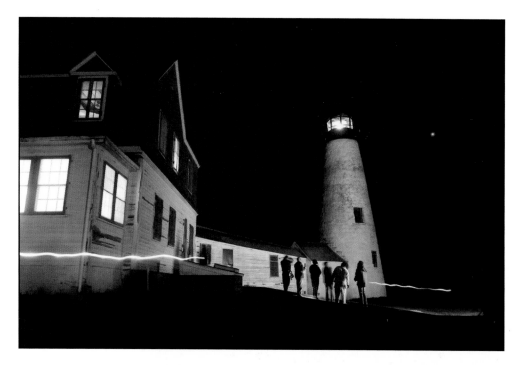

As midnight approaches, a group of would-be ghost hunters (left) emerge from the old keeper's home by Wood Island Light off Biddeford to search for signs of outdoor spirits. A ten-second time exposure tracks their flashlights. An 1896 murder-suicide on this island has led some to believe the area is haunted. Working in his shop, Ernest Libby Jr. of Great Wass Island (below) completes a lobster boat replica, *Myrtle Belle,* named for his wife. Jonesport–Beals Island has a long tradition of boatbuilding, including model boats.

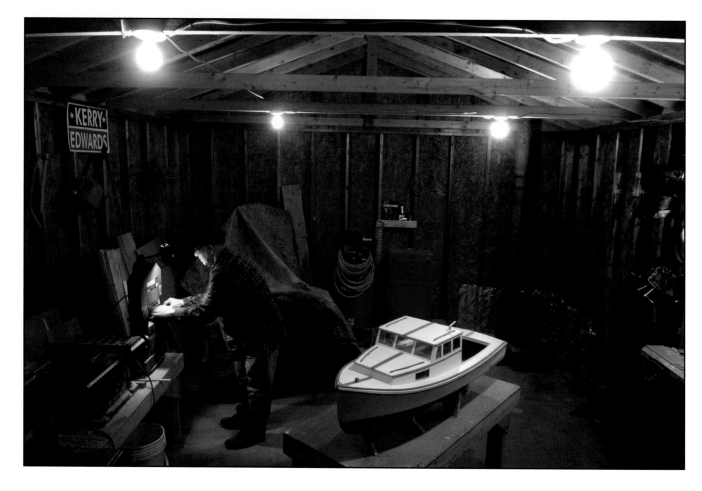

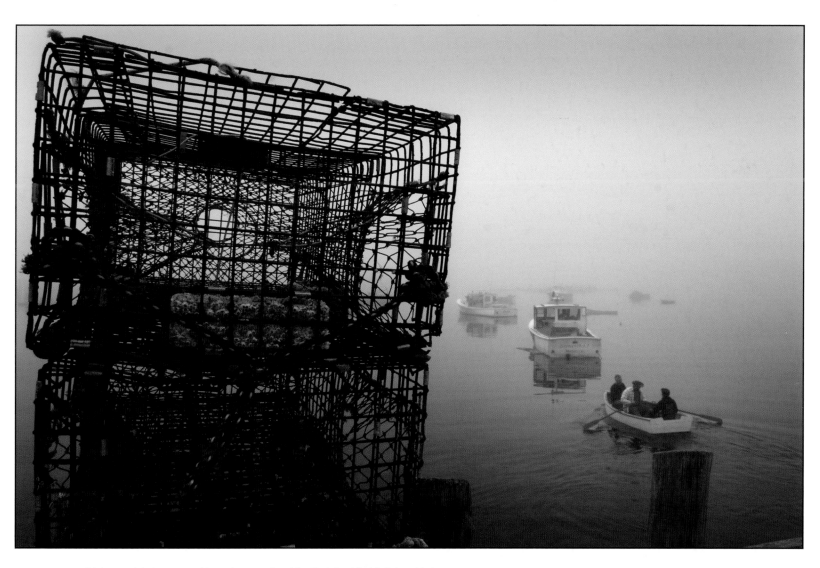

At dawn a lobsterman and two sternmen head for their boat in Matinicus Harbor.

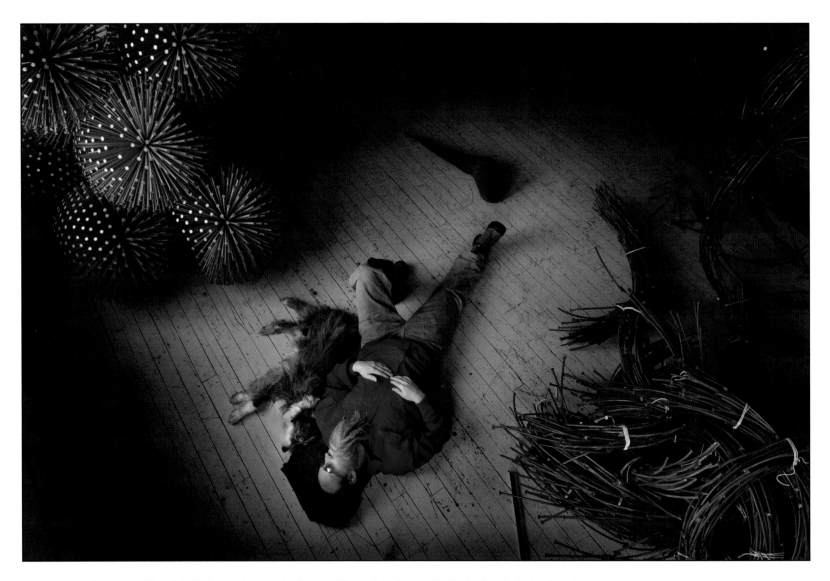

Sculptor and Bowdoin College professor John Bisbee of Brunswick relaxes with his dog Bonnie during downtime at his studio. Bisbee says he often works though the night.

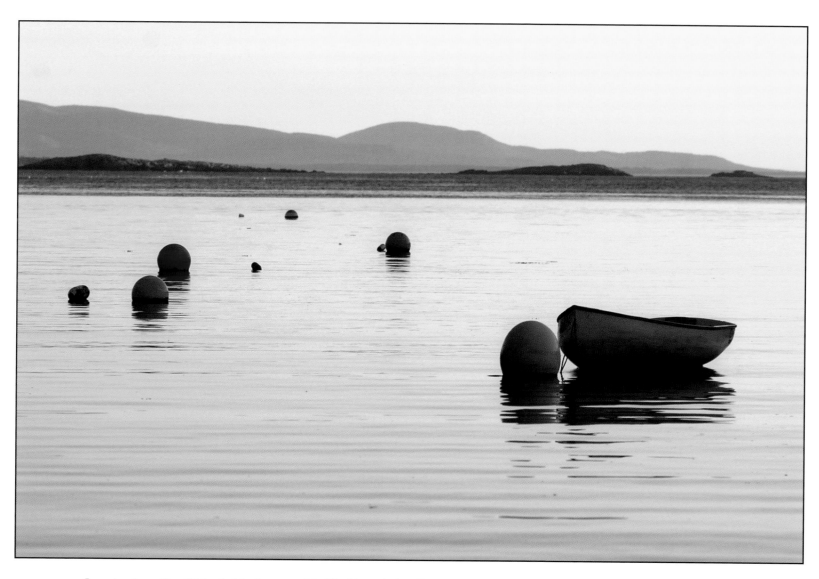

Dawn breaks on Blue Hill Bay in this view toward Cadillac Mountain from Frenchboro. The town of Frenchboro is comprised of twelve islands: Long Island, Mount Desert Rock, Black Island, Placentia Island, Pond Island, two Green Islands, Drum Island, Great Duck Island, Little Duck Island, Crow Island, and Harbor Island.

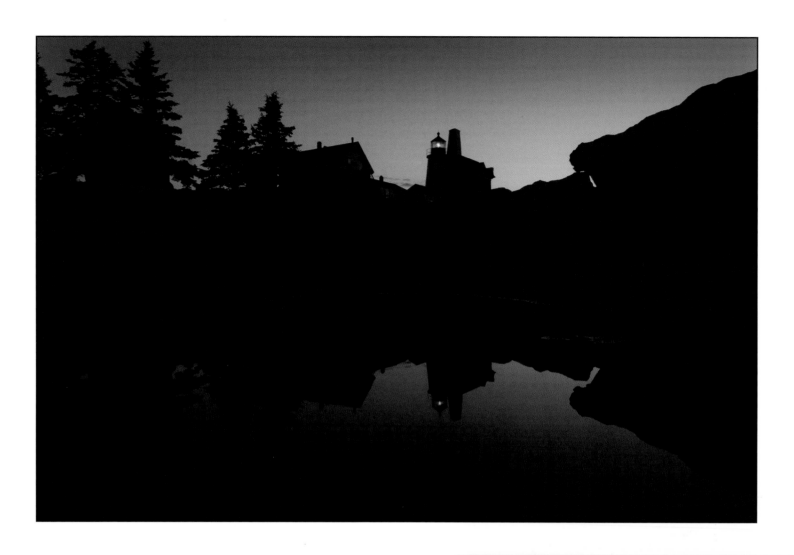

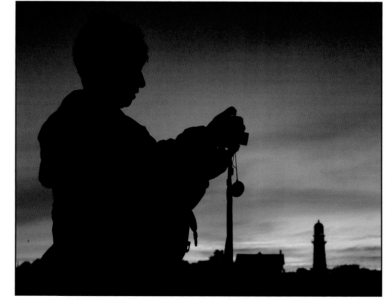

Pemaquid Point Light in South Bristol (above), commissioned in 1827
by John Quincy Adams, stands at the entrance to Muscongus Bay. A visitor
from California (right) uses a digital camera to capture the sunset from
Dyer Point in Cape Elizabeth. One of the lighthouses of Two Lights State
Park looms against the evening sky.

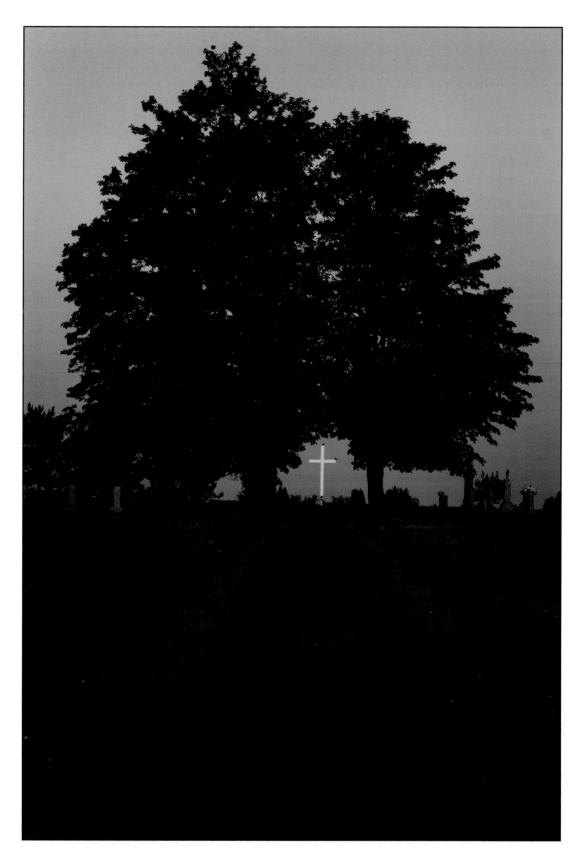

The first rays of dawn illuminate a crucifix in the St. Agatha cemetery in Aroostook County.

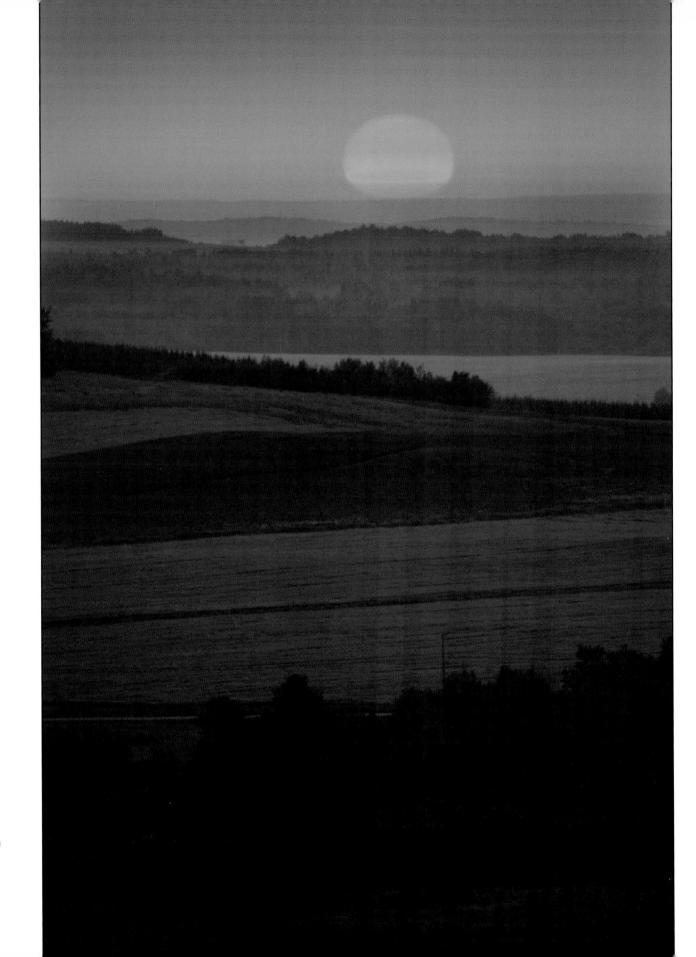

A July morning dawns in
St. Agatha.

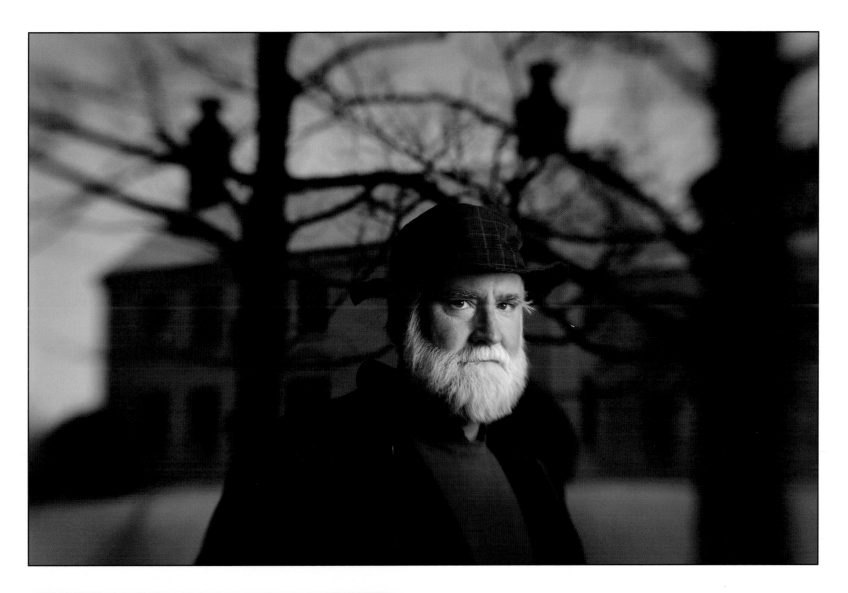

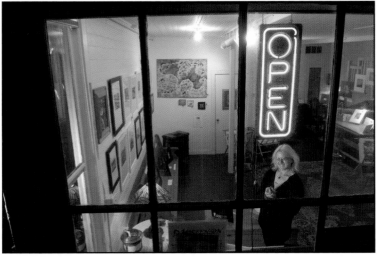

The oldest part of Nicholson Baker's South Berwick farmhouse (above) predates the founding of the United States by sixty-five years. A prize-winning author who previously lived in New York and California, Baker says he and his family choose Maine because "Things are simpler here." Debi Mortenson of Stonington (left) operates the D Mortenson Gallery and works in a variety of colorful media.

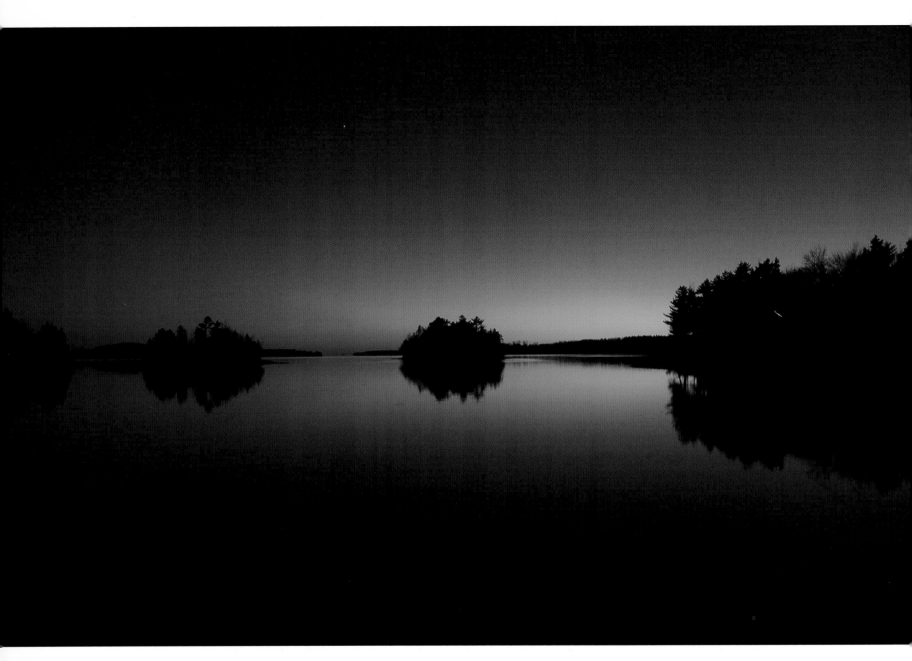

Stars are mirrored in the tranquil ocean waters off Harpswell at dusk (above).
At dawn a lobsterboat heads into a wharf in Portland Harbor for bait (opposite, top).
Every day Dennis Provencher and his dog Amber (opposite, bottom) greet the sunrise
off Old Orchard Beach even when clouds threaten.

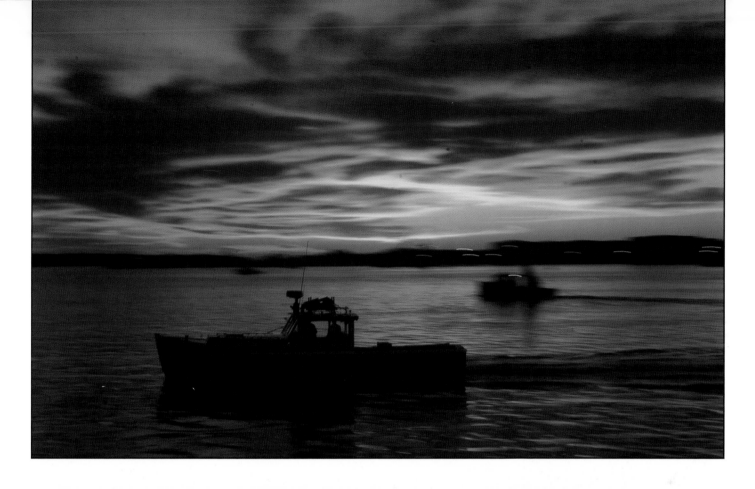

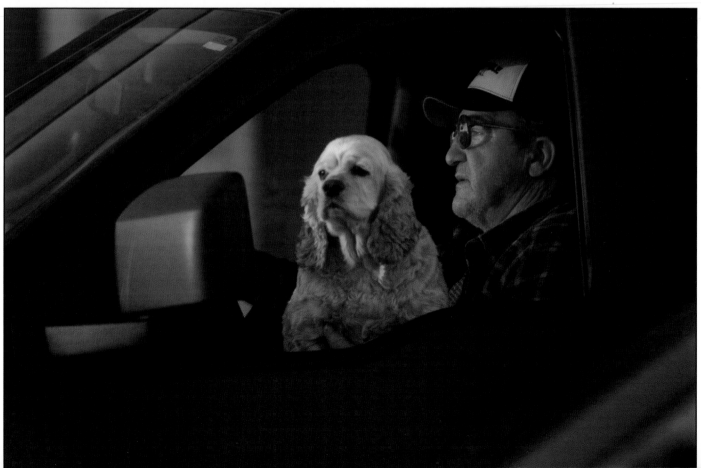

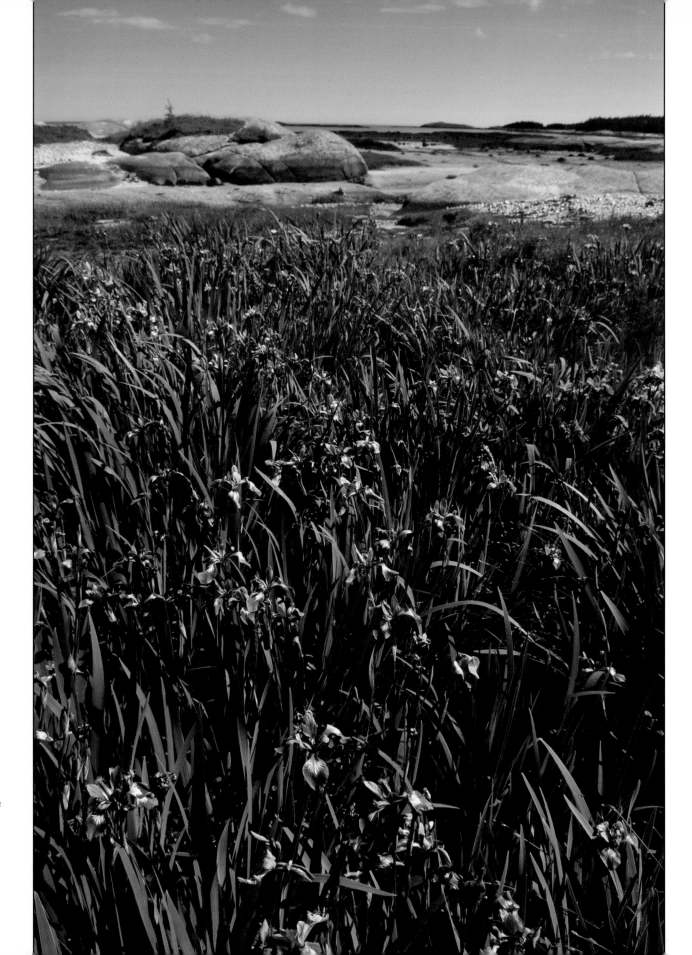

Wild irises bloom at the Great Wass Island preserve in Beals. The preserve features 1,540 acres of Down East coastal beauty.

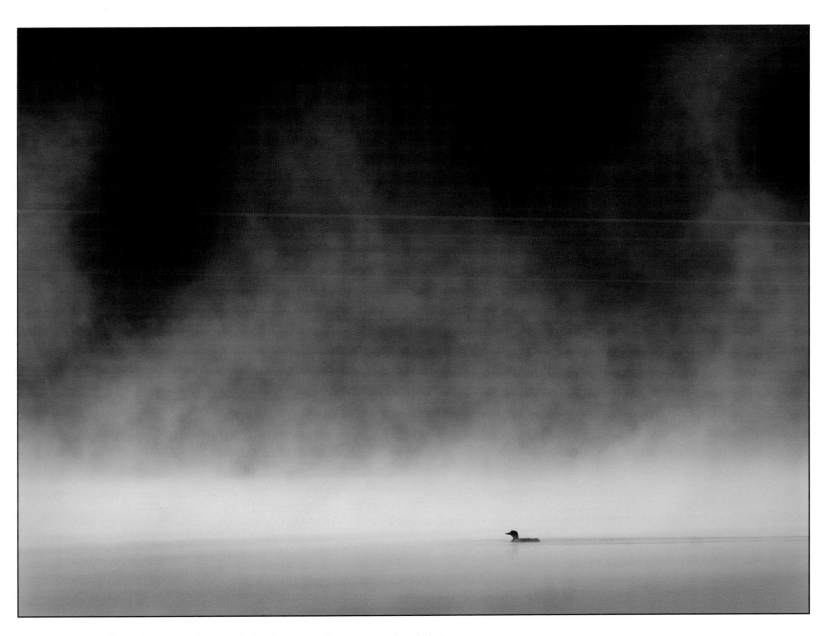

The first cold morning of autumn finds a loon navigating in mist on the relatively warm waters of Depot Pond in Lebanon.

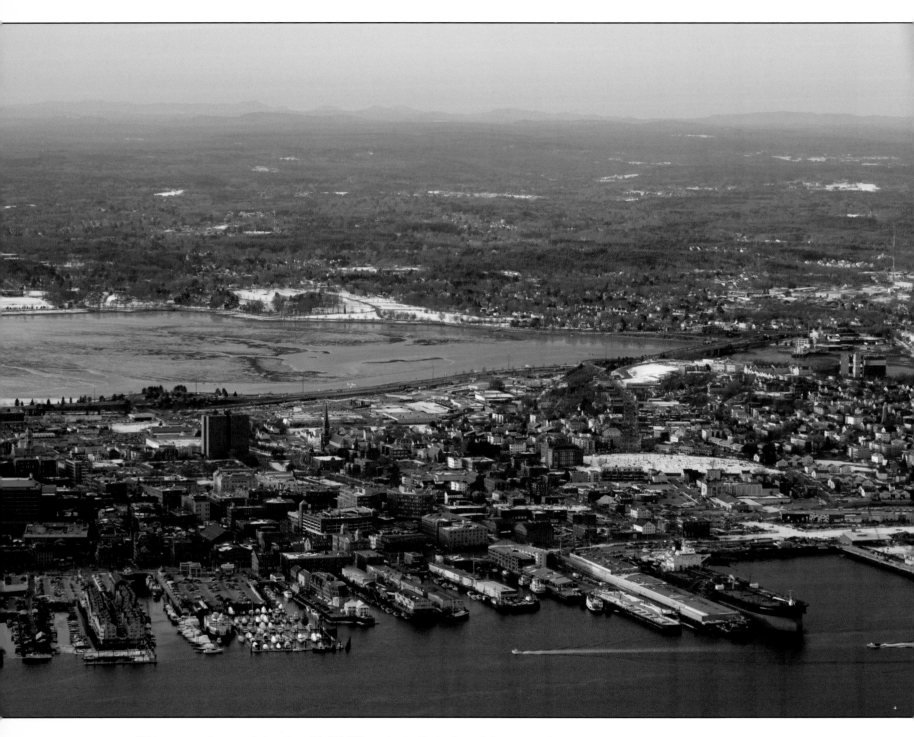

With a metropolitan population of roughly 230,000 people, the Portland area is home to nearly one quarter of Maine's population. Mountains of western Maine and New Hampshire are visible in the background.

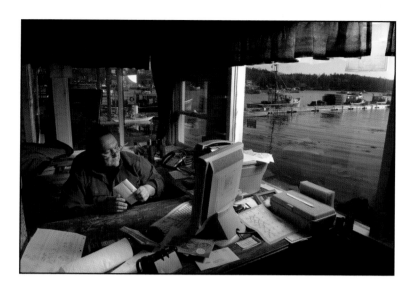

Doug Pilon (left) monitors lobster prices from his office at Bailey Island Lobster Company. Winter dawn breaks beyond Portland Head Light in Cape Elizabeth (below).

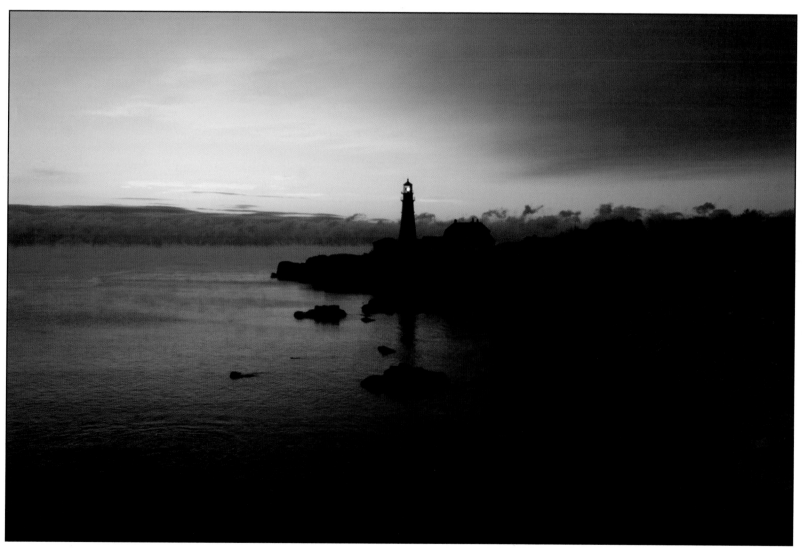

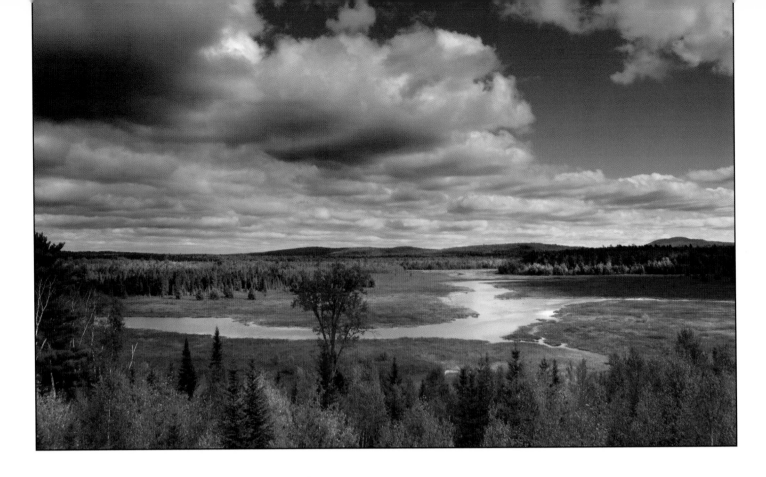

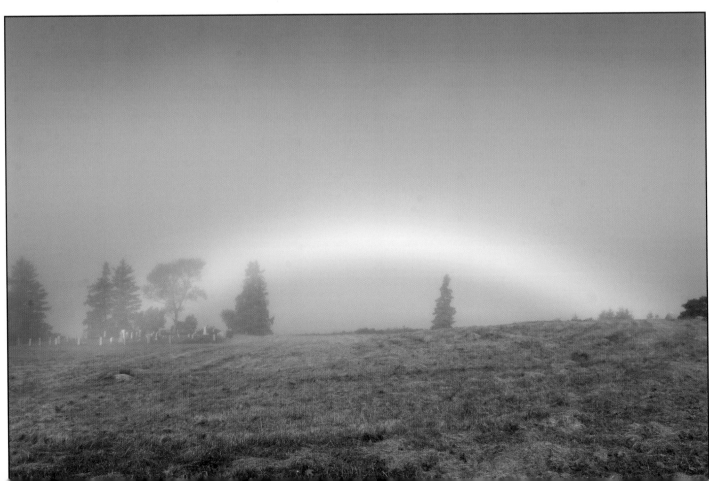

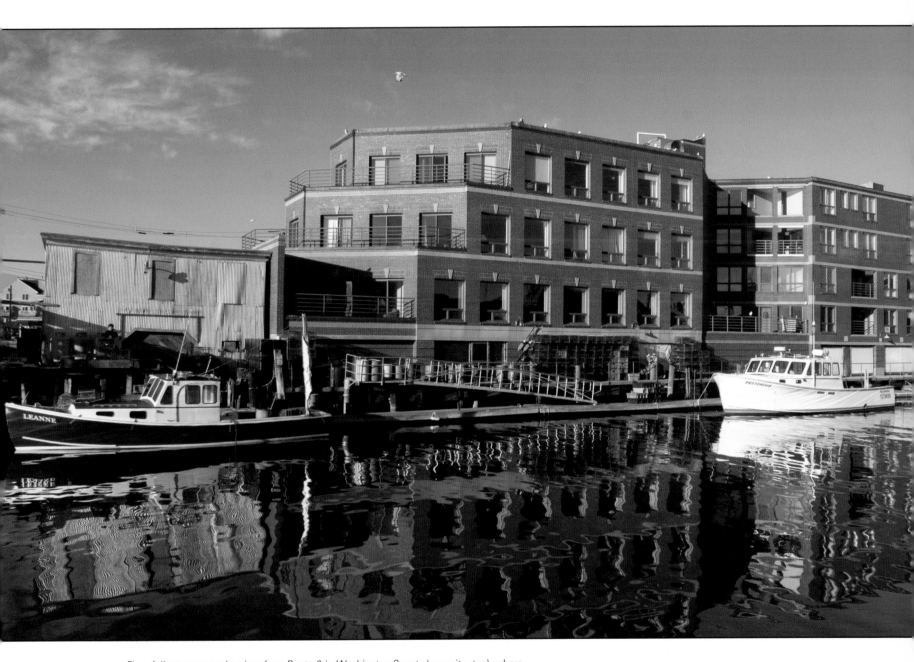

Fiery foliage accents the view from Route 9 in Washington County (opposite, top), where
the stretch of state highway between Bangor and Calais is known as "The Airline." A fog-
bow on Isle au Haut (opposite, bottom) forms where fog and clear skies meet. Old and new
meet on the Portland waterfront (above), where functional fishing buildings are giving way
to attractive condominiums.

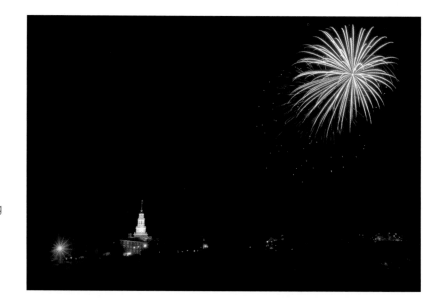

Fireworks explode beyond Colby College in Waterville (right) during an October celebration. Rulon Simmons of Rochester, New York (below), uses a medium-format camera to catch the beam of Portland Head Light slicing through persistent fog at dusk.

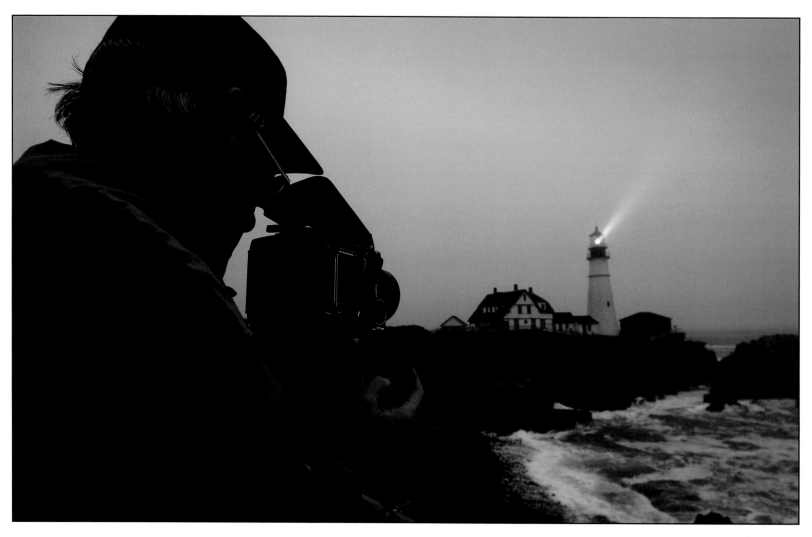

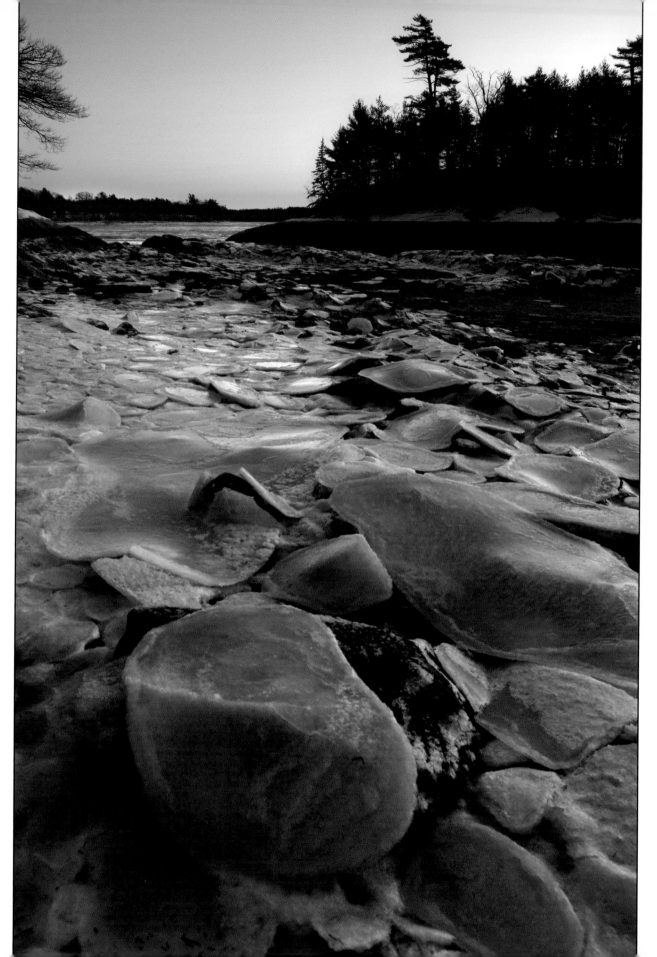

Frozen ocean water forms pliable oval discs at Wolfe's Neck Woods State Park in Freeport.

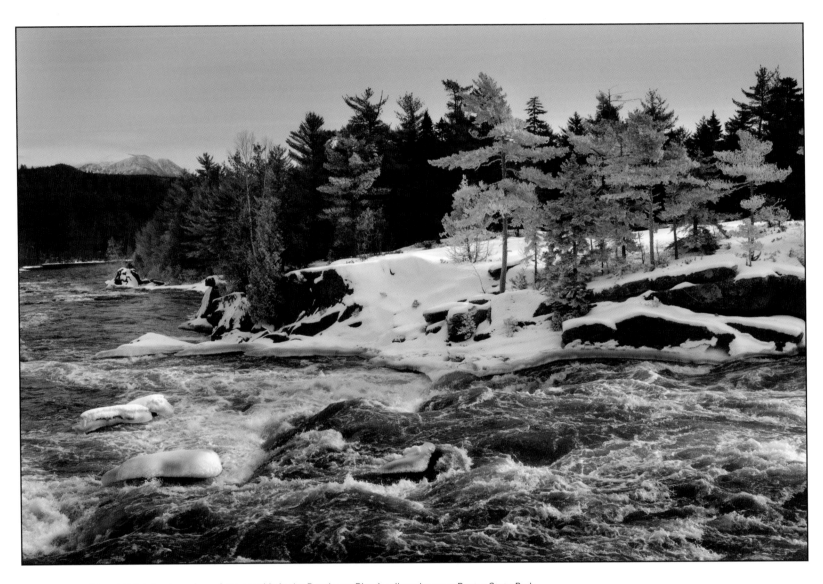

Mount Katahdin rises above frozen rapids in the Penobscot River's cribworks, near Baxter State Park.

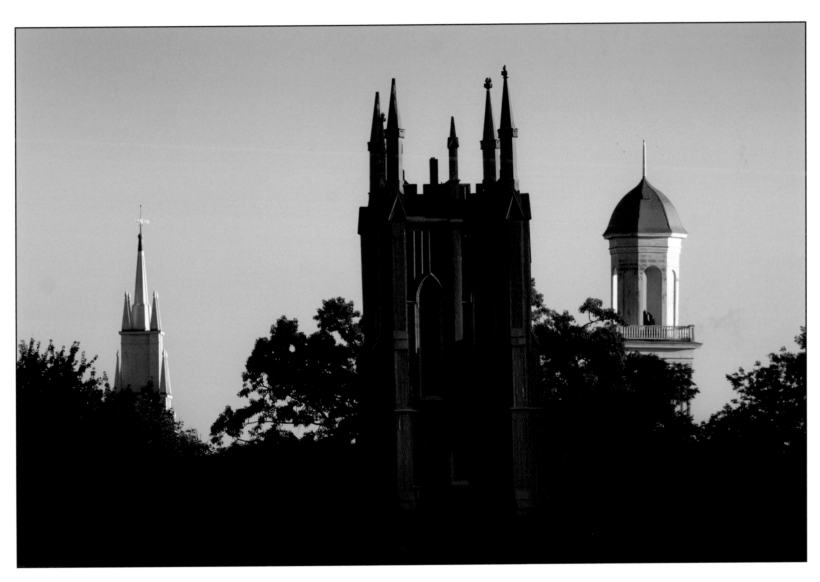

The so-called Chocolate Church in Bath is flanked by the Winter Street Church (left) and First Baptist Church (right).

A coating of predawn ice (above) creates a beautiful foreground for Goat Island Light off Cape Porpoise. The view from the study at Admiral Robert E. Peary's home on Eagle Island (left) is spectacular. On April 6, 1909, Peary, accompanied by Matthew Henson and four Inuit natives, planted the American flag at the North Pole. They were the first people to reach the northernmost point on earth.

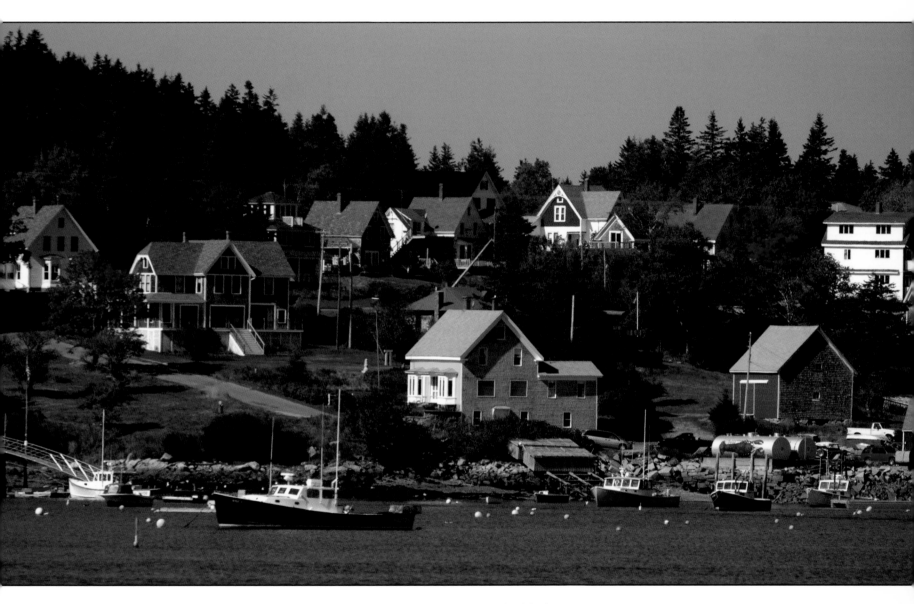

Swan's Island, off Mount Desert Island, has a year-round population of 350 that nearly triples in summer.

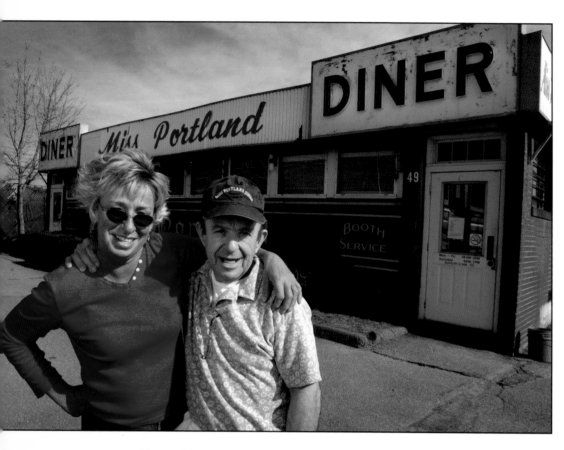

Manager Mary Barnes and owner Randall Chasse of the Miss Portland Diner felt both "happy and sad" when their landmark Portland eatery closed.

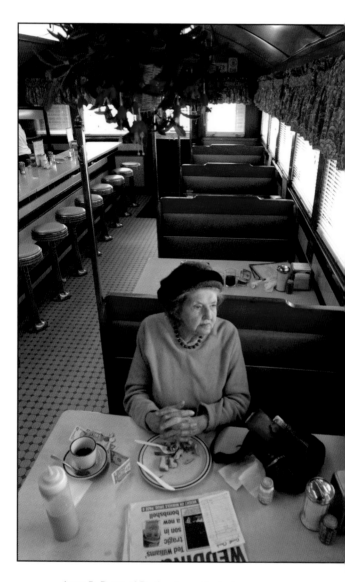

Anne B. Foote of Portland was the last customer for the last lunch served at the Miss Portland Diner.

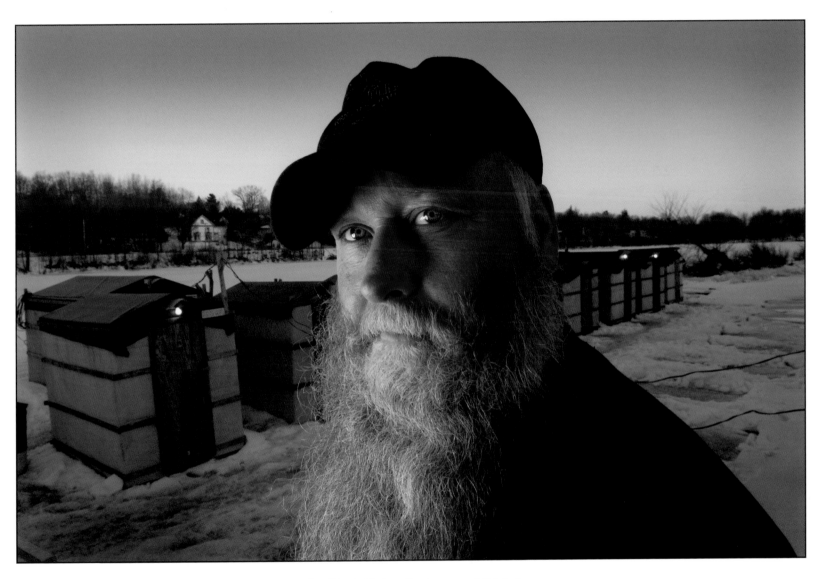

Jimmy Worthing rents smelt shacks on the Kennebec River in Chelsea. Smelts are small fish that frequent Maine's tidal rivers in winter. The river is usually hard enough for the shacks by early January, but in colder years fishing may begin in December.

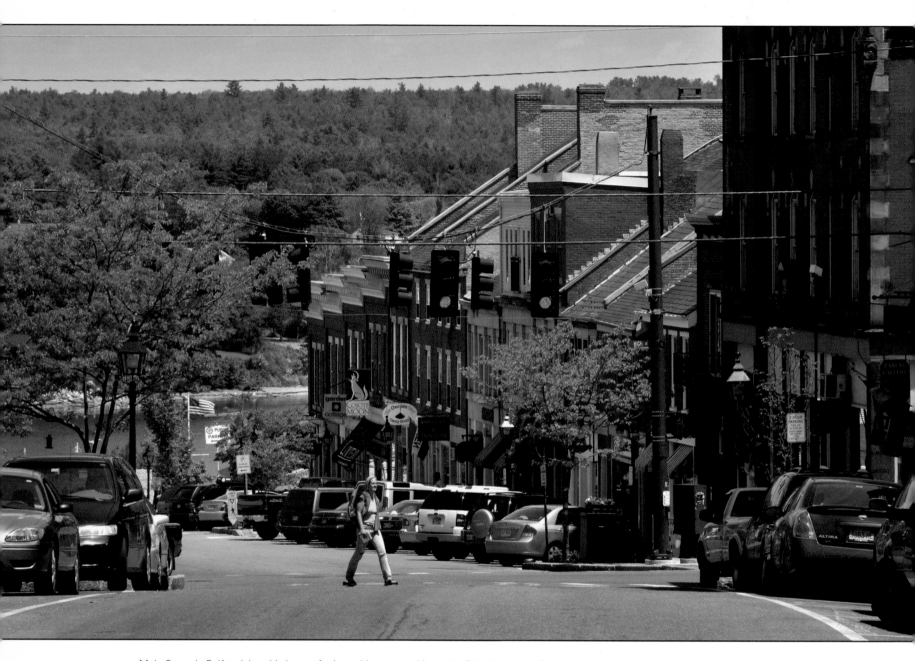

Main Street in Belfast (above) is known for its architecture and its angle. Dick Haehnel of Scarborough (opposite, top) wears a broad smile as he talks about the 1953 Dodge pickup that he rescued years ago from a Mississippi farmer's field. The truck was "so covered with red mud that you couldn't see anything." he said. Now he proudly prepares it for the Old Orchard Beach auto show. Eighty-seven-year-old Ozzie Sweet (opposite, bottom) relaxes in the great room of his York Village home before a picture of bison he photographed in South Dakota. Sweet, still an active photographer, has at least seventeen hundred magazine covers to his credit.

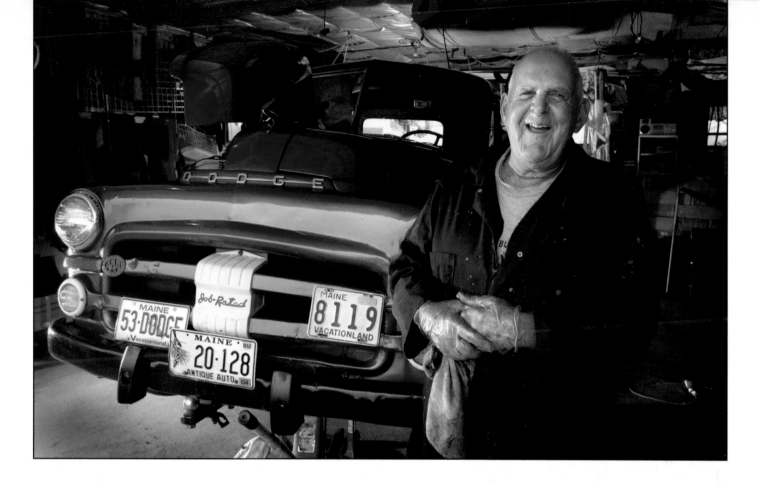

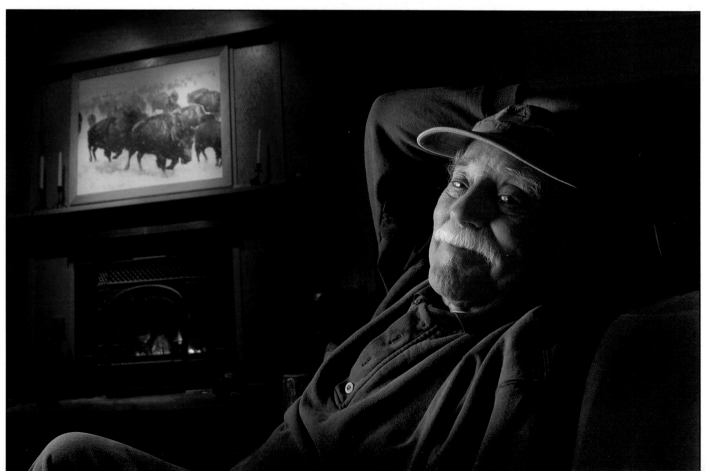

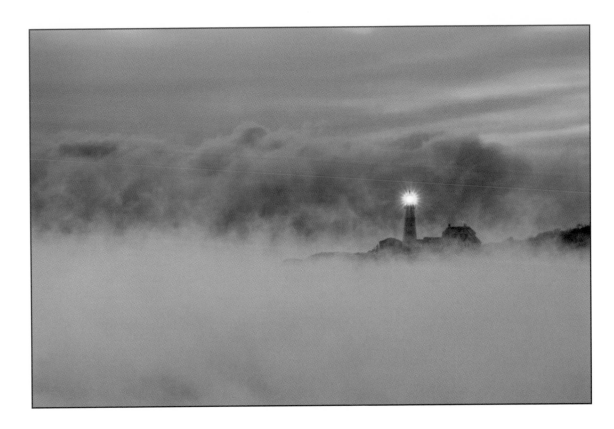

Portland Head light in Cape Elizabeth sends out a warning at dawn.

Vince Clarke travels the world as part of the long-running electronic-music duo Erasure, but he has put down roots in coastal Maine not far from Pemaquid Point Light in Bristol.

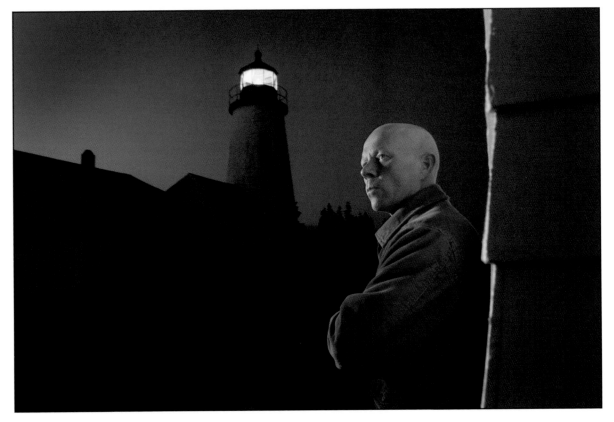

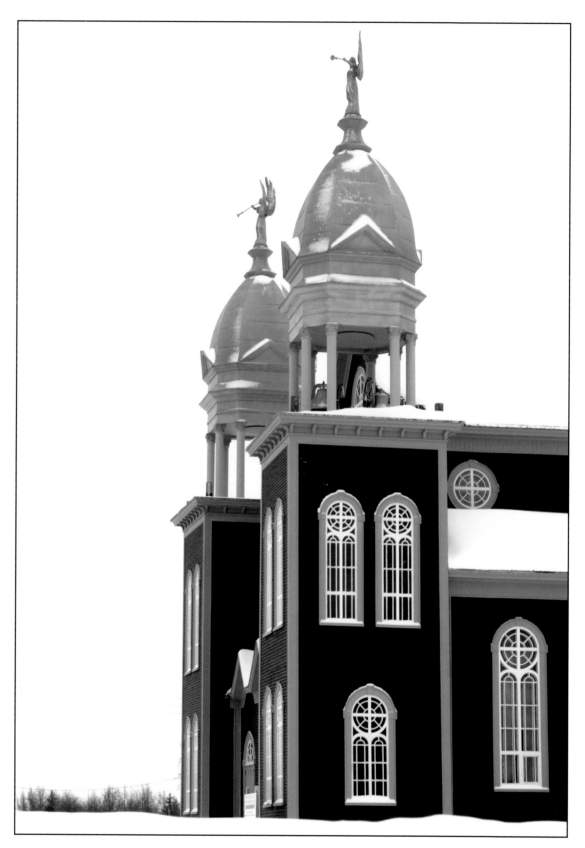

The Musee Culturel du Mont-Carmel in Grand Isle is under restoration.

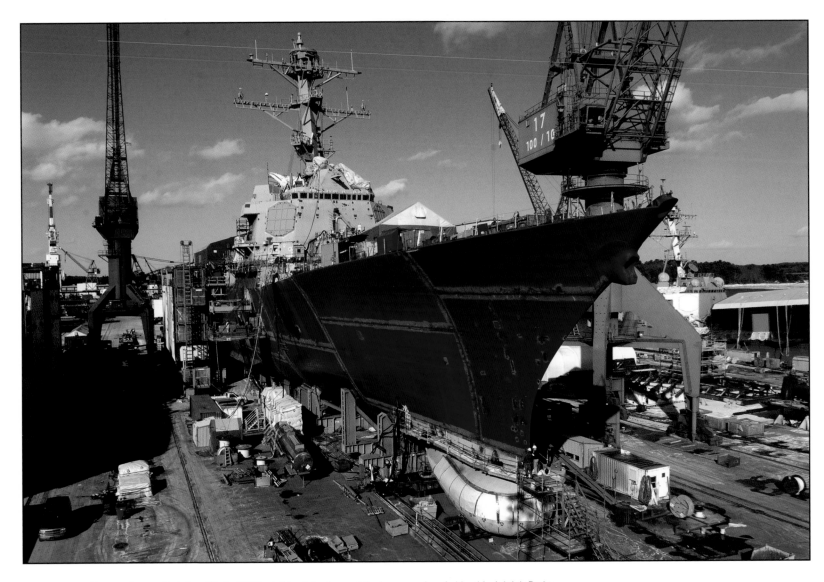

Two workers at Bath Iron Works (BIW), visible at the base of the bow, are dwarfed by this Arleigh Burke DDG51-class destroyer. BIW is one of Maine's largest private employers, with a history stretching back to the nineteenth century. "Bath Built is Best Built," or so the saying goes.

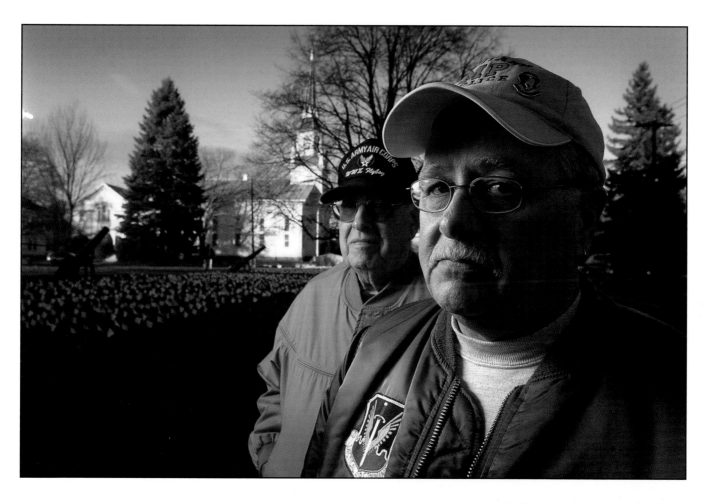

Michael Williams, Sr., of Oakland (above, foreground) was one of five veterans arrested at Veteran's Memorial Park in Waterville after they began removing white flags symbolizing fallen American soldiers. "It's not an appropriate place to have an antiwar statement," he says. With him is his father, World War II veteran Malcolm Williams of Waterville. Military pride runs deep in Maine. Five fishermen (right) cast for striped bass shortly after dawn off Parsons Beach in Kennebunk, where the Mousam River meets the sea.

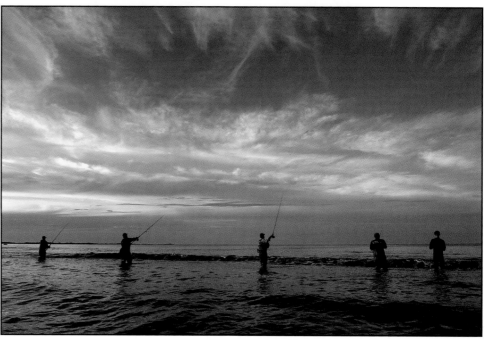

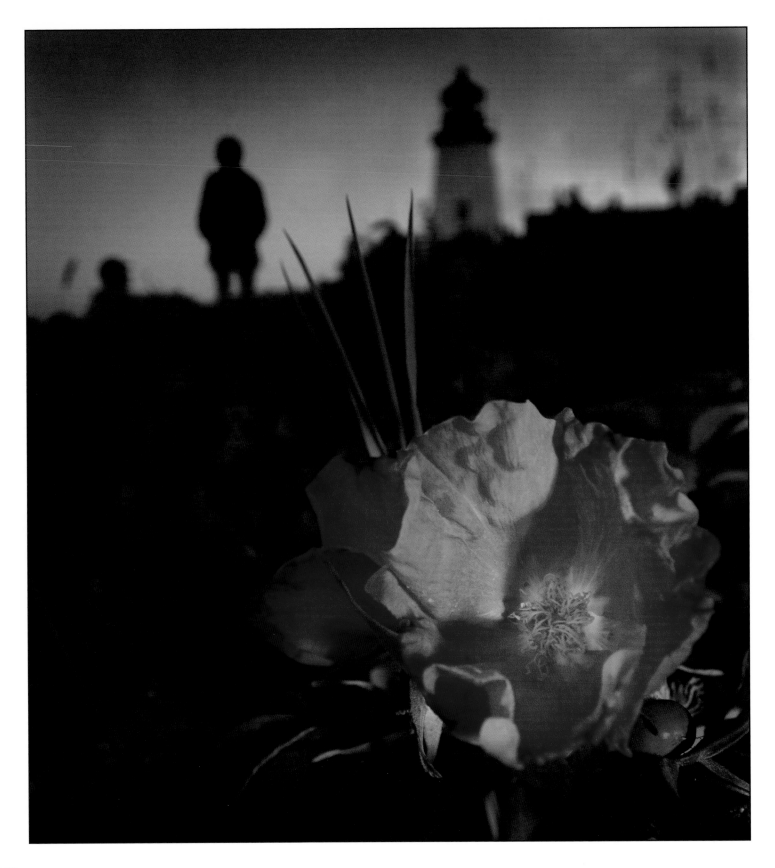

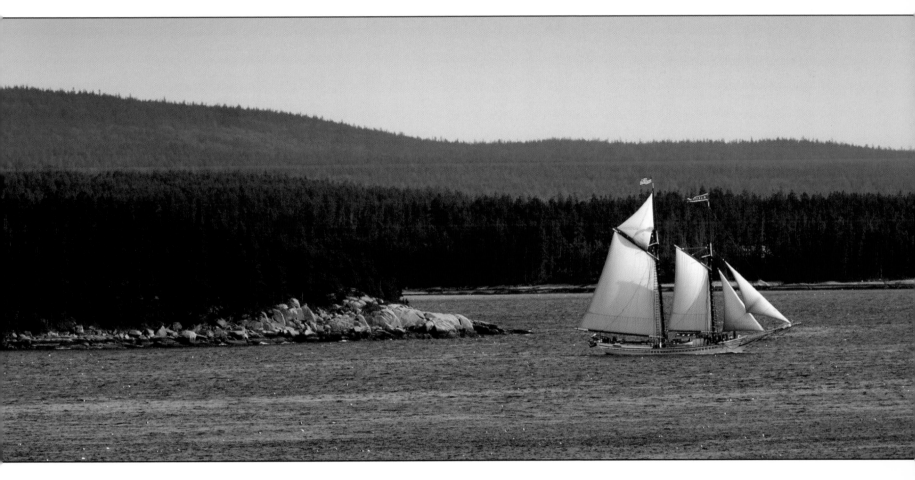

At dusk a colorful beach rose (left) provides a vibrant foreground to Pemaquid Point Light in Bristol. A schooner comes up into the wind off Deer Isle (above).

## AUTHOR'S NOTE

The phone call from Publisher Webster Bull at Commonwealth Editions propelled me into the daunting task of capturing Maine in all her stunning and humble beauty, and it's been an extraordinary, 24,273-mile, 16-county adventure. This state is big, with more than 33,000 square miles and more than 3,500 miles of coastline. I've enjoyed the humor, intellect, and kindness of people from one end of the state to the other. I thank Webster for believing in me and my art, giving me the encouragement and freedom to create this book.

I've discovered so much about Maine and her people during this journey, from the summer beauty of wild irises by the ocean at Beals Island, to the resolve of Amish children walking to school in a true blizzard. I've enjoyed sharing the daily ritual of waiting for the sun to break over the ocean at Old Orchard with Dennis Provencher and his dog Amber, and marveling at the wonders of a Bristol dawn with artist Frema Rauh at Pemaquid Point.

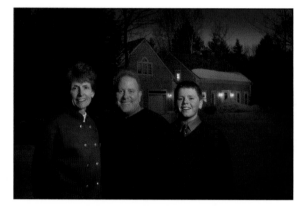

*Karen Dobbyn, Fred Field, and their son Robert*

James Sheppard taught me about the courage of his fellow Tuskeegee airmen in World War II; Olympic gold medalist Seth Wescott impressed me with his snowboarding prowess, grace, and style. Brenda Jepson showed me a passion for the land and the people of New Sweden. And I'll never forget the endless fields of potato blossoms in The County where the distinctive Acadian-French-Scottish dialect contrasts with Maine's better-known coastal accent.

At the northernmost tip of New England, it was fun watching Germaine Ouellet play poker in Estcourt Station, Maine, while her husband sat across the kitchen table from her—in Canada. All 1.35 million Mainers share the state's single 207 area code, except for the Ouellets and the eight other residents of Estcourt Station, who use Quebec's 418.

Then there's the scent of the ocean, the clambakes, the pine forests . . . I could go on and on, but I'll let my photos describe the rest of what I love about Maine all year long, whether it's close to 100 degrees or 45 below.

I've really enjoyed this journey. Many thanks to Maine and her great people.

## ACKNOWLEDGMENTS

Special thanks to the many people who helped make this book a reality: My wife Karen Dobbyn and our son Robert Eaton Field for their love, Carolyn Eaton Field for teaching me how to see, Edwin Field, Leslie Field, Analaide Eaton, Fred Eaton, Robert Dobbyn, Shirley Dobbyn, Doris Lang Dobbyn, Edward Dobbyn, Barbara Egan, Richard Egan, Angus King, Anne Lenihan Rolland for the beautiful design of the book, Chuck Cochrane and Brian Fitzgerald of Blethen Maine Newspapers for graciously letting me share some photos, Holly Eddy for awesome marketing, John Barnett/4 Eyes Design for the cool cover design, Ellen G. Reeves for expert editing — from Paris no less, Roderick Firth, Bill Brett, Bill Hubbell, Greg Born, J. Walter Green, Howard Reben, Tom Tajima, Ken Johnson, Brendan Peter Anthony Grant, Greg Derr, Casey Grant, Barbara Walsh, Doug Preston, David Sutherland, John Beaman, Dave Wilcox, Cynthia Finnemore Simonds, Gene Willman, Jay Reiter, Justin Ide, Paul and Doris Seiler, Jim Barns, Jessica D'Amico, John Harrington, Brenda Jepson, Gretchen Piston Ogden, Laurie Hyndman, Susan Gentile-Hackett, Jim Thomas, Maria Dempsey Gould, Sharon Daley, Rob Benson, Letitia Baldwin, James Bogart, Amy Kennedy, Kevin Bouchard, Elizabeth Ackles, Carl Ackles, Bill Cunningham, Sandy Marsters, Bob Melville, Jen Podis, Dan and Tricia Small, Frances Small, Ben Waterhouse, Ralph Munroe, Clay Copp, Jane Orans, Dr. Randall Brune, Jerry Waterman, Jim Fossett, Gina Ferrazi, Jeff Silva, Dr. Michael Swords, Debee Tlumacki, Lisa Bül, Gary Higgins, Marta Lavandier, John Bohn, Richard Green, Peter Weinberger, Brian Speer, Laura Meader, Leo Trudel, Karl Pepin, Frema Rauh, Katherine Egan, Nicholson Baker, James Sheppard, Ted Greene, Rodney Stacey, Wallace Pryor, Dale Pryor, Donna Augustine, Guy Leblanc, Germaine Ouellet, Edmond Levesque, Karen McGonagle, Christina Shipps, Mike and Kathy Nichols, Kyle Quinn, Bill Clark, Brian Tripp, Sheldon Morse, Qiamuddin Amiry, Greg Zielinski, James and Susan Cavanaugh, Gregg and Gloria Varney, June LaCombe, Wilmot "Wiggie" Robinson, Marika Cowan, Jerry Flewelling, Haley Eberhart, Ernest Libby, Jr., John Bisbee, Jaed Coffin, Deb Mortenson, James Babiarz, Dennis Provencher, Doug Pilon, Ozzie Sweet, Dick Haehnel, Vince Clarke, Malcolm Williams, Michael Williams, Sr., Jimmy Worthing, and the countless Mainers along the way who did me a good turn. I'm forever grateful!